ast date

D1093029

Whistler *Lithographs*

Whistler *Lithographs*

AN ILLUSTRATED CATALOGUE RAISONNE
COMPILED AND EDITED BY MERVYN LEVY

WITH AN ESSAY ON 'WHISTLER THE PRINTMAKER' BY ALLEN STALEY
Associate Professor of Art History Columbia University

JUPITER BOOKS

LONDON 1975

INTRODUCTION AND CATALOGUE © 1975 MERVYN LEVY
'WHISTLER THE PRINTMAKER' © 1975 JUPITER BOOKS (LONDON) LIMITED
ALL RIGHTS RESERVED
FIRST PUBLISHED IN 1975 BY JUPITER BOOKS (LONDON) LIMITED,
167 HERMITAGE ROAD, LONDON N4.
SBN 904041 255
PRINTED BY TINLING (1973) LIMITED, PRESCOT, MERSEYSIDE.

ERRATA

Page 8, paragraph three, line 10: the reference in parentheses should read:

(W. 5 and 7, Plates 10, 11, 15, 16 & 17)

As above, line 11:

(W. 10 and 11, Plates 21 & 22)

Page 10, paragraph one, line 13: as above:

(W. 156, Plate 194 and page 13)

Page 10, paragraph two, lines 3 and 4: as above:

(W. 49 and 50, Plates 80 & 81)

Page 20, paragraph four, line 3: as above:

(Plates 8 & 9)

Page 20, paragraph four, line 7: as above:

(Plate 178)

Page 20, paragraph five, lines 4 and 5: as above:

(Plate 54)

Page 23, note 9, second line: as above:

(Plates 8 & 9)

The colour reproductions on pages 9, 13, 21 and 24 are entries 193, 194, 195 and 196 respectively in the Plates section.

ACKNOWLEDGEMENTS

The author and Publisher are greatly indebted to the undermentioned museums, galleries, and individuals who have assisted with the preparation of this book in so many ways and who, in many instances, have given permission to reproduce works in their collections: The British Museum; Arthur Driver and P & D Colnaghi & Co; The Art Institute of Chicago; The Library of Congress; The Military Academy, West Point; Reginald Williams and Peter Moore of the Department of Prints and Drawings, British Museum; Graham Reynolds of the Victoria and Albert Museum; Clifford Hall; W. J. P. Smith; my young son Ceri Levy, who helped with the arrangement of the photographs; and especially Professor Andrew McLaren Young, Mr Roger Billcliffe and the Department of Art, University of Glasgow.

FOR MARIE

Allen Staley
Associate Professor of Art History, Columbia University

WHISTLER THE PRINTMAKER

Whistler the printmaker has not been seen with the same eyes as Whistler the painter. Critical reaction to his paintings has always been mixed. For much of his working career the standard response of most critics was derision. By the end of his life (he was born in 1834 and died in 1903), his reputation had climbed considerably, and he had a substantial band of followers ready to proclaim him the greatest artist of the nineteenth century. But by then more advanced critics and historians were beginning to find it difficult to make him fit comfortably into the pattern of development of Impressionism, Post-Impressionism, and modern art. Roger Fry did not have much use for him, and in Germany Julius Meier-Graefe could dismiss him as a defrocked Pre-Raphaelite. Subsequently, opinions have fallen and risen once again, but few people today would place Whistler on the same level with his great French Impressionist contemporaries. The suspicion lingers that this wit and dandy, who spent such a disproportionate amount of time creating his public image, should not be taken quite seriously as a painter.

In the more specialized realm of the graphic arts Whistler has fared better. The claims of his biographer and hagiographer Joseph Pennell that with Rembrandt he was one of the two supreme printmakers of all time seems excessive, but it is difficult to deny Whistler a pre-eminent position among nineteenth-century printmakers. More than any other individual, he was responsible for the great flourishing of the medium of etching during the latter years of the century. A group of his prints shown in a dealer's gallery in Paris in 1862 were praised by Baudelaire, and in the following year in London William Michael Rossetti was beginning to draw comparisons with Rembrandt. Although Whistler's prints did not always draw unanimous praise, they were granted respectful attention far more readily than his paintings.

Whistler's activity as a printmaker began before he decided to become an artist. In the summer of 1854, at the age of twenty, he was expelled from West Point. He worked for a few months in a locomotive factory, which was owned by relatives; then through family connections he got a job in the drawing division in the U.S. Coast Survey in Washington. He had studied drawing at West Point, and in Washington he was set to work etching topographical views of coast lines. The training he received in the Coast Survey has been credited with providing the

basis of technical proficiency for Whistler's later activity as an etcher, but the importance of this period should not be overstressed. It may have provided Whistler's introduction to the craft of etching, but etching, unlike engraving, is not in itself a difficult medium and is not difficult to learn (witness the number of amateurs, such as Whistler's brother-in-law Seymour Haden, who became accomplished etchers). Whistler remained at the Coast Survey less than four months, from November 1854 to February 1855. The two plates upon which he is known to have worked while there show a schematic set of conventions used for impersonally precise topographical delineation. These plates were, of course, reproductive, based upon drawings by other hands.

Following his departure from the Coast Survey, Whistler decided to go to Paris to become an artist. He remained in Paris from 1855 to 1859. There he received whatever training he can be said to have had as a painter, but from all accounts he worked harder at *la vie de bohême* than at serious study, and for the rest of his life his painting was to suffer because of his lack of technical proficiency. With the exception of *At the Piano* (Taft Museum, Cincinatti, Ohio), painted in the winter of 1858–59, just before his move to London, Whistler's pictures from this period are unimpressive, but during these years he was also making etchings, and they are another matter. In 1859, when the first painting Whistler submitted to the Salon, *At the Piano*, was rejected, two etchings were accepted. By then, he had already, in November 1858, published *Douze eaux-fortes d'après nature*, twelve etchings (or thirteen including the title page) which are now usually known as *The French Set*. Although these prints are still immature compared to what Whistler would do in the following years, they are of far greater interest and quality than the paintings he was doing concurrently.

The first lithographs with which Whistler's name can be associated date as early as 1852, when he was at West Point, but these were juvenile efforts, reflecting no interest in lithography *per se*. In 1878 and 1879, under the encouragement of Thomas Way, who had a lithographic establishment, he began to experiment with the medium. Although he made only seventeen lithographs before his departure for Venice and then did not return again to the medium until 1887, these were serious experiments in which the artist explored the range of possibilities open to him. Some are close stylistically to his etchings of the 1870s; others, which are, strictly speaking, lithotints rather than lithographs, reproduce the tonal qualities of Whistler's Nocturnes in oil (W. 5 and 7, pp. xxx). Two, *Gaiety Stage Door* and *Victoria Club* (W. 10 and 11, pp. xxx), are rapid sketches of street scenes made from Thomas Way's window. These two lithographs anticipate the informal observation of much of Whistler's work done in Venice and in England after his return, and their compositions have a corresponding informality. The abbreviation of detail into a few random touches of the crayon is extremely precocious. Whistler did not publish these prints immediately, but in 1887, when he took up lithography again, he published six of his early lithographs, including *Gaiety Stage Door* and *Victoria Club*, under the title *Notes* (a title which emphasized the

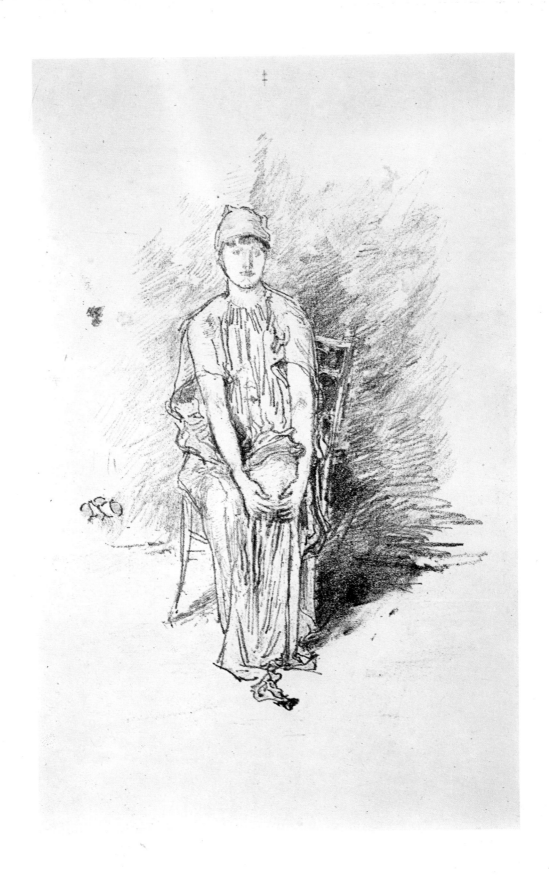

brief nature of these works, in contrast to the terms *Arrangement, Harmony*, and *Symphony* which Whistler used for his larger works). The *Notes* were not very successful with the public, but they marked the beginning of a period, lasting until 1896, in which Whistler devoted himself to lithography. The earlier efforts were drawn directly on the stone, but after 1887 he worked mainly on lithographic transfer paper, which allowed him to sketch more easily in the open air. It also allowed him during the years 1892 to 1894, when he was living in Paris, to put his sketches in the mail and send them to London to be printed. In Paris Whistler also experimented with color lithography, inspired by the example of younger French artists such as Toulouse-Lautrec and Bonnard. The process Whistler followed, preparing separate stones for each area of color and mixing and varying the tints for each before printing, was complex and time-consuming; for *The Draped Figure Reclining* (W. 156, p. xx) he printed from six separate stones. Because of the amount of time they required, he made only a handful of color prints, but these have a restrained subtlety which is distinct among the work of the time.

The subjects of Whistler's black-and-white lithographs range from nude models posed in the studio to journalistic on-the-spot records of the funeral of President Carnot, which Whistler wanted to sell to the *Pall Mall Magazine* (W. 49 and 50, pp. xxx). The most appealing are scenes of a comfortable out-of-door life: nurses and children in the Luxembourg Gardens, or a few friends taking tea in the artist's own garden. A large number are intimate and informal portraits of Whistler's friends and family. In 1888 he had married Beatrix Godwin, the widow of the architect E. W. Godwin; it was her liking for lithography that encouraged Whistler to devote his chief activity to it during the early 1890s, and after her death in 1896 he abandoned it almost completely. Among his most poignant works are two lithographs showing her confined to bed shortly before her death. Other late lithographs show his mother-in-law and his two sisters-in-law, his brother, and his sister Deborah, now become Lady Haden.

That his Haden relatives loom large in Whistler's early prints, while his family and his new in-laws have a comparable place in his later ones, is a reflection more of the pattern of Whistler's life than of his artistic development. Yet, when we remember that his most famous work is his painting of his mother, whose portrait he also etched, we should not discount the importance that family affections held in Whistler's art, despite his claims to the contrary. His statement that 'art should appeal to the artistic sense of eye or ear, without confounding this with emotions entirely foreign to it, as devotion, pity, love . . .', may indicate how he wanted the public to view his art, but art often says more than what the artist wants it to say. In Whistler's hands, the graphic arts became an extremely personal means of expression, possessing a directness and an intimacy which he rarely allowed to appear in his oil paintings. His prints are enriched by embodying devotion, pity, love, and a whole range of human feelings which, however he may have tried, he did not suppress.

Thomas R. Way

(1) INTRODUCTION TO THE CATALOGUE OF 1896

When, some nineteen years since, Mr Way described to Mr Whistler the various methods in use in lithography, he hardly thought that he was sowing seed which should produce in time so splendid a harvest of masterpieces as is to be found among the drawings recorded in this catalogue. Lest it should be said (seeing that in this last year or two the numbers have grown so greatly) that it is too early to make a catalogue of the lithographs, there is the precedent of Mr Whistler's etchings, which were first recorded by Mr Thomas when their numbers were rather less than the lithographs are now, and it is to be hoped that the latter will continue to increase until they are as numerous as the etchings. This is all the more to be hoped as it is clear that in lithography the master has found a medium which is more sympathetic and personal even than the copper-plate. In proof of this, attention need only be drawn to the two marvelous works, the *Early Morning* and the *Nocturne*, prints which stand alone in the history of lithography.

In 1878, after trying the medium, it was proposed to issue privately to subscribers a limited number of proofs of drawings, at intervals as they should be ready, under the title of *Art Notes*, but the response was so limited that not more than half a dozen copies each of the *Limehouse* and *Nocturne* were so published. One can only imagine that this failure was caused by the exceedingly low reputation to which lithography had then fallen as an artistic medium. In the same year, Mr Theodore Watts-Dunton, who was editor of a magazine called PICCADILLY, asked Mr Whistler to do illustrations to be issued in that periodical, and he produced four drawings—*The Toilet, Early Morning*, and *The Tall Bridge* and *The Broad Bridge*—for this purpose. Only two of these, the first and the last, were issued, as PICCADILLY then finished its short career, and owing to the little time given to print these works, not more than a dozen proofs could be pulled by hand-press before the stones were put into the machine and the impressions for publication printed.

Later, in 1887, after Mr Whistler's return from Venice, the set known as *Art Notes* was published by Messrs Boussod, Valadon & Co. Thirty sets, on large paper, signed, were issued in brown paper covers at four guineas each. The set consisted of six lithographs, *Limehouse, Nocturne, Battersea Bridge, Reading, Gaiety Stage Door*, and *Victoria Club*. As the *Limehouse* drawing failed to yield more fine impressions than those already taken, it was omitted from the seventy

sets on smaller paper at two guineas. Since this time Mr Whistler has issued his lithographs separately, in the same way as his etchings, mostly as proofs on old Dutch paper.

The numbers have been extremely limited, and Mr Whistler has now fixed 100 as the maximum. Several of the later drawings have been issued in very large numbers by various periodicals. In THE WHIRLWIND three were printed, viz.: *The Winged Hat, The Tyresmith*, and *Maunder's Fish Shop*. THE ALBEMARLE issued *Chelsea Rags*; THE STUDIO, *Gants de Suède, The Long Gallery, Louvre, La Robe Rouge*, and *Savoy Pigeons*; and THE ART JOURNAL *Les Bonnes de Luxembourg*. Later on, THE STUDIO published *The Smith's Yard*, and THE ART JOURNAL *Little Evelyn. Firelight—Joseph Pennell. No. 1* was printed as a frontispiece to LITHOGRAPHY AND LITHOGRAPHERS, and *The Doctor* was printed in THE PAGEANT. But the numbers for these publications were not printed from the original stones, three or four transfers being taken from them and put on other stones, for the printing. L'ESTAMPE ORIGINALE issued a very limited number of the *Draped Model Seated*, the portrait of *Stéphane Mallarmé* was printed in Paris as a frontispiece to a volume of the poet's works, and the *Girl with Bowl* in L'IMAGIER.

As the peculiar processes used in lithography are not generally understood, it may be as well to give a short account of them here. The lithotints are made with washes of ink on the stone, and an occasional use of chalk, and scraped; these afford only a limited number of proofs. The chalk drawings made direct upon the stone are quite simple and explain themselves. Those made on transfer paper are done so only for the portability of the material; being transferred directly to the stone, they become as much lithographs as if drawn on it. Although the earlier ones are quite simple chalk drawings, it will be found that Mr Whistler has worked, later on, with the stump, and has produced effects quite remarkable in their exquisite quality; this is notably the case with the Luxembourg and Savoy Hotel drawings.

Again, in some of his latest and perhaps most successful lithographs, he has had paper prepared for himself of a character adding greatly to the difficulty of drawing and handicapping the printers in transferring the drawing safely to stone. In spite of these difficulties, however, it has produced such splendid results as *La Robe Rouge, La Fruitière de la Rue de Grenelle*, and the forge of the *Passage du Dragon*. In these all trace of the mechanical grain found in the regular transfer papers was lost, and the result much more closely approaches that of a drawing made on stone.

Although it has been thought worth while to mention these facts as characteristic of the man in sparing himself no pains to attain the exact results he set before him, one can be confident that all connoisseurs will turn again with equal delight to the drawings of shops and forges made in London streets, to the St Bartholomew's subjects, and more still, perhaps, to the delightful *Nude Model Reading, The Winged Hat*, and the charming lightly draped figures

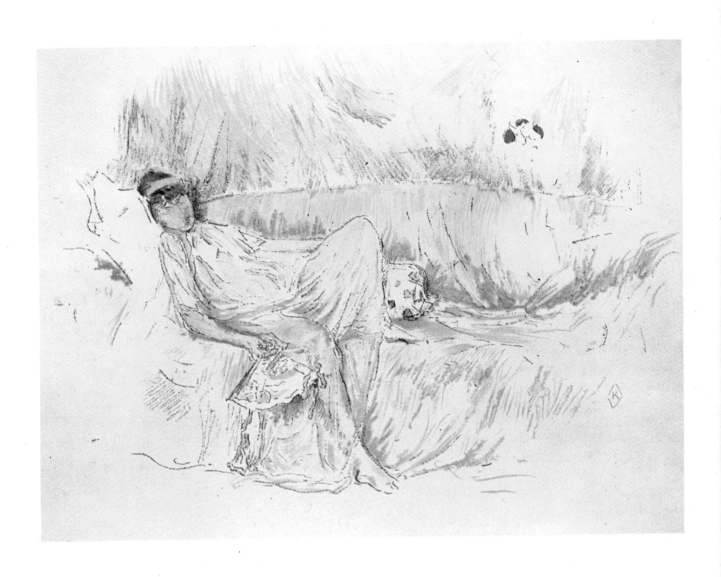

13

which were done before Mr Whistler settled in Paris.

The latest series of drawings, mostly of smithies and forges, makes yet another development, showing the mastery of the painter, with a spontaneity of execution that is altogether wonderful. In the course of reproduction of these many drawings there have naturally been some failures, and there have been some which, after a good many impressions from the stone, were discarded and never actually published. The first of these are not included in the catalogue at all, but the latter have been, and a note added that the drawing has been erased. This has been done in order that this little catalogue should be as absolutely complete as possible. All these lithographs—with the exception of Nos. 65, 66, 67, 100, and 101, which were printed in Paris by M. Belfont—have been printed for Mr Whistler by Mr Thomas Way, whose aim has been to give in the prints absolutely and exactly what Mr Whistler himself made in his drawings, in the simplest and most direct manner, and without any addition whatever. This statement refers to the subjects included in the first edition, *i.e.*, Nos. 1 to 130. Of the remainder, those printed in Paris are - so indicated; the rest were printed by Mr Way.

It was intended at first to keep this catalogue entirely to the black and white drawings, but as Mr Whistler has included two of his color prints in his first exhibition of lithographs, they have been added near the end. In date they should come about the same time as the drawings of Vitré. A very limited number was printed in Paris by Belfont; and owing to the break-up of the firm of printers, there is little likelihood of their being reprinted. In addition to these two, a description is given of Mr Whistler's first experiment in color, which, although not completed, is yet very charming.

(2) INTRODUCTION TO THE CATALOGUE OF 1905

The first edition of this catalogue was published at the end of June, 1896, and its introduction began by expressing a hope that the list would increase until its numbers might surpass the number of the Master's etchings. One hundred and thirty lithographs were then described; 160 are accounted for in the present edition. But of the 30 additional subjects, at least 20 might have been included in the first edition. They were drawn at various times, and condemned by their author after very few proofs had been pulled, and were not thought of sufficient importance by him to be included in the first edition. Some of the remaining ten were also probably drawn before 1897. So the hope was not fulfilled, and the stone received but little of Whistler's work during the last few years of his life.

A few months after the issue of the first edition, Whistler broke off his long friendship with the author and his father (for reasons quite unconnected with lithography), and withdrew all the stones upon which his drawings were, from his printer's keeping. They remained in the cellars of his solicitors until about a year

after his death, when an edition of 25 proofs was reprinted from certain of them by Mr Goulding for his executrix, and the drawings erased from the stones. Now lithographic stones with drawings upon them require attention from time to time, especially if they be grained stones, as the greater part of Whistler's were, else the ink dries too hard, so that when they are next taken in hand after a long interval they are liable to suffer serious deterioration in the effort made to recover the printing qualities. The delicate work weakens by neglect, and the stronger parts are apt to become over strong in the printer's effort to recover the weaker. The result is a muddy, heavy-looking print when compared with an early proof.

It is most desirable that the whole edition of a lithograph should be printed at once, as soon as the artist is finally satisfied with the proof. Unfortunately, Whistler treated his lithographs as he would his etchings, where no harm could come by pulling three or four proofs and putting the plate aside. He generally ordered a few proofs from a number of subjects, repeating the supply as his stock was absorbed. So few proofs were taken of many of the subjects that these must have inevitably become exceedingly rare, should the stones have suffered harm; and it is to be feared that this did actually happen to a considerable number, as only 55 out of almost 100 subjects handed over to Whistler's solicitors were exhibited in London in 1904, when the reprints were shown. These 55 are indicated in the catalogue, and Mr Goulding is to be congratulated on having succeeded as well as he did with so difficult a task. A record had been kept, as long as they remained in Mr Way's charge, of the number of proofs which had been pulled, so it has been possible to indicate at least approximately the number of each subject printed. These numbers, however, do not include the preliminary trial proofs, which were generally made upon good ordinary white paper whilst the drawing was subject to alterations, or, indeed, whilst it was being gradually brought up to its proper strength of color under the printer's hands. In some cases this occurred at the second or third impression; in others, notably in the case of such drawings as those made in Paris and at Lyme Regis upon the thin textureless transfer paper, many rough proofs were necessary before a passable proof could be obtained. It was in consequence of an attempt to hurry matters unduly that the three beautiful designs, *Mother and Child*, Nos. 2, 3, and 4, were wholly or partially failures, Whistler insisting upon all three being put through the process of etching before they were strong enough to bear it. Except with these three, and the early experimental drawing of *Old Battersea Bridge*, there were practically no accidents to any of Whistler's lithographs whilst under Mr Way's care. Some of the drawings which were condemned as not worth printing are only to be found on the white paper; this is the case with the *Study, Maude Seated*, as also with the early states of the Lyme Regis drawings and others. This paper may be taken as a fairly safe guide as to the print being an early copy; it may also indicate an immature state, in spite of every effort to destroy all such copies.

It is well known that Whistler was extremely fastidious in the matter of the paper upon which his etchings were printed, and he was equally so with his litho-

graphs, though with less justification. He was wedded to old Dutch paper, and constantly collecting it, and it was his custom to send packets to his printer to be used for his proofs. Some would be excellent, but much would be so stained and mildewed that, had he been printing himself, he would have surely rejected it. Yet, although there was rarely a sufficiency of perfect sheets to print the proofs ordered, it was with the greatest difficulty that he could be got to consent to a modern hand-made paper being used. Even old Chinese paper, which has always been admitted to take the most brilliant and perfect proofs, and at the same time to wear the stone less than any other, did not quite please him: perhaps it was too white. Most hand-made papers incline to hardness and to an uneven and rough texture, which do not help to prolong the life of the lithograph.

It is no easy task to describe in words the changes in the early states, lithography differing from etching in that one finds a gradual lightening or darkening of a drawing, without being able, as in etching, to point out the addition or deletion of definite lines. There can be no question about Whistler's work, that the final finished state is always that most to be desired; the earlier states leading up to it are only interesting to the student, as showing the loving care and infinite pains which he spent on attaining the exact quality and effect he aimed at, and that no detail was too small or unimportant to escape his notice.

It will be seen that no attempt has been made to describe the states of the color prints. To do so would probably require a separate description of each proof. On one occasion an examination of about ten proofs of the *Red House, Paimpol*, showed that the red color was changed each time. Yet it is also a somewhat remarkable fact that such a large proportion of these drawings should have satisfied him at once, without the slightest retouching. Of course lithography is a 'positive' process, the drawing being in black upon a white or light ground, and this will have helped to bring about such a result, so different from that in a like number of his etchings. On very many occasions the drawings on transfer paper were sent from Paris by post, and the proofs sent in return being quite to his liking, a number of further proofs were printed without his touching the stone in any way. Yet it was not quite plain sailing for his printer when he began stumping upon transfer paper in his own special way. Before any of these drawings were laid down on the stone, experiments had to be made with drawings done in the same manner, to find out how best to treat them. He really did ask the medium at times to give him extraordinary results, and it did not fail him—witness the amazing delicacy of the *Early Morning* and *The Tall Bridge*, the solemn stillness and repose of the *Nocturne*, the fullness of the last of his lithotints, *The Thames*; or again, note the suggestion of the color and texture of the stone in the *St Giles-in-the-Fields* and another drawing made directly afterwards, *The Little London Model*, where the color and modelling of the flesh obtained with the stump puts it on all but the same level as the *Little Nude Model Reading*, which is pure point work; or yet one more—if it is possible to select where each subject has its special qualities to claim study—that perfectly beautiful and pathetic vision of his sick wife lying upon the

couch at the Savoy Hotel, so wrongly entitled by him *The Siesta*. And whilst these and many others show how readily lithography responded in black and white subjects, his success was no less marked in the few color prints which he did. The wonderful proof of the *Draped Figure Reclining* is a technical triumph indeed, in addition to its claim for its own dainty loveliness. Thus, after remembering such works, one wonders what he can have meant when he wrote the note printed as a preface to the catalogue of Mr Pennell's exhibition of lithographs in October, 1896. In it he writes: 'And he only could, with the restricted means of the lithographer—and restricted indeed I have found them—have completely put sunny Spain in your frames. . . . "Tout lasse—tout passe"—and I am glad you manage this exhibition before others, persevering, have strained the limits of lithography beyond the ken of us beginners.'

What art is there which is without restriction? Or what art is there which offers a wider range of means than lithography? Chalk, wash, stump upon the plain stone or upon a prepared half tint, or upon many kinds of transfer paper, in black and white, or in color without limit. He used them all, and succeeded in mastering all with the least effort to himself, and at the end of this work he writes of 'the restricted means of the lithographer' and calls himself a 'beginner'! He who himself successfully made the art produce new and unfamiliar results! It is likely to be many years before there comes another master to add to the many sides of lithography others than those in each of which Whistler has left a masterpiece. No, his verdict is neither just nor generous! This same exhibition, it will be remembered, was the cause of a lawsuit brought by Mr Pennell for libel against the SATURDAY REVIEW and Mr Walter Sickert, in consequence of an article written by the last named, in which he protested against the word 'lithograph' as applied to drawings made upon transfer paper. During the trial Whistler appeared on behalf of the plaintiff, and defended his own use of transfer paper in a perfectly logical manner. The verdict was for the plaintiff, with damages. It perhaps is as well that the question was raised openly, although it must be confessed that twelve good men and true in a jury box, picked without any consideration of fitness to examine into artistic matters, are hardly the proper authority to settle such a point. They evidently judged on the point of fact that the print is the lithograph, not the drawing, whether it be upon stone or paper. The meaning of the Greek words from which its name is derived seems to make some people think that that could be no true lithograph which was not drawn or written upon stone, but lithography is a modern printing process, little more than a century old, and was not at first even known by this name; and whilst the prints from the stone, on which has been laid down the drawing made upon transfer paper, are legitimate lithographs, they may also claim that in the transferring to stone they have had to pass through a critical process from which drawings made directly upon stone are exempt. This, whilst of no importance to the artistic result, should at least help to free such drawings from the imputation of being an easy and inferior substitute for direct stone work. The original cause of objection was probably due to the mechanical grain at first found

upon these transfer papers, which gave to the print an appearance of being a reproduction of a drawing by some mechanical process. Such, however, is not the case, and Whistler's earlier efforts at using transfer paper triumph in spite of this drawback.

A word of explanation of the manner in which color prints are produced may be of interest to those who are not familiar with it. A drawing of the subject, mostly in outline, is first made and printed in black or gray. Then further drawings are made either on transfer papers or stones, one for each color to be printed, and each tint so placed that it shall fall in its right position on the proof. In such subjects as *The Red House, Paimpol*, where only three printings are used, the matter is not very difficult, but when such a subject as the *Draped Figure Reclining* is in hand, with six printings, the problem is extremely complicated. In printing, each color takes a considerable time to dry, and so, under the most favorable conditions, such a print will take some days before a complete proof can be seen; but each color, when added, modifies the effect of the whole, and may render some alteration of a previously printed color desirable. Yet to make any such change it is necessary to start again from the beginning. Thus some small idea will be gained of the difficulties to be mastered, as well as the time spent, in perfecting even one proof. Of course, when once the colors are settled and proofs passed, the printer can make many similar proofs in little more time than it has taken to print one. It is very greatly to be regretted that none of these color prints went beyond the first complete proofs, which probably vary very greatly one from the other.

Whistler had arranged a series of these color prints, and Mr Heinemann advertised their publication under the title of *Songs on Stone*, but none were issued.

EDITOR'S INTRODUCTION

If Whistler were making prints today, without doubt he would be one of the greatest technical experimenters of his time. His approach to lithography, etching and drypoint has a casualness about it which belies the strength and depth of his technical genius. The elegant wizardry of his touch in the context of a complex media, is as the sleight of hand of the conjuror. He was an adventurous artist who was forever searching for new devices that would enable him to move even closer to perfection. He brought to the exercise of lithography, especially, a freshness of approach and a technical skill both inventive and sometimes controversial. In 1897 an article by Richard Sickert in Frank Harris's *Saturday Review* attacked Joseph Pennell's method of making lithographs by the use of transfer paper. Whistler, who himself used the same method, was drawn into the lawsuit which followed, and appeared as a witness for the plaintiff. The article argued that to pass off drawings initially made on transfer paper as lithographs, was as misleading as to sell photogravures as etchings. The attack was of course substantially unjustified, and patently ignorant. The method had been in existence since the invention of lithography by Seinefelder who, although unable to perfect the process himself, recognised its potential and considered it a most important part of his invention. It was Whistler who substantially perfected the process. The results obtained through this technique had been largely unsuccessful until Whistler experimented with it, creating exquisite greys with the very lightest pressure on the white transfer paper with the tip of the crayon. The case against Sickert and his Editor, Frank Harris, was heard in the King's Bench Division on 5 April 1897. In his evidence, with delicious and characteristic arrogance, Whistler said he was disgusted that 'distinguished people like Mr Pennell and myself are attacked by an absolutely unknown authority; an insignificant and irresponsible person'. To which, Counsel for Mr Sickert countered with the observation that an insignificant and irresponsible person could do no harm. But Whistler's riposte that 'Even a fool can do harm' must have helped to shape a verdict which found for the plaintiff. Pennell was awarded damages of £50;[1] hardly a fortune, but a great deal more

[1] Details of the case are documented in Vol. 11 of the Pennell's *Life of Whistler*.

than Whistler had himself won nearly 20 years earlier, when in 1878 he was awarded a farthing damages in his libel action against John Ruskin.

Until this time Whistler and Sickert had been relatively good friends, the younger artist (Sickert) having been apprenticed in 1882 to the older master who a little later on was a great help to him in the printing of his etchings. Inevitably the lawsuit led to a rift in this relationship.

The method which Sickert had condemned is one since frequently used by lithographers. The initial drawing is made with lithographic ink on a sheet of specially coated paper (transfer paper) and is then transferred to a stone (or plate) in much the same way as a child's transfer is transferred to another surface. Sickert's quarrelsome attack is perhaps best seen as an example of the eccentricity which often characterised his ideas and his general behaviour in later years. Coming from one who frequently resorted to the use of press photography as a source of inspiration, his purisitic offensive against Pennell was a piece of downright cantankerousness.

Whistler's flair for a more experimental approach to the practice of lithography was realised early. When first he took up lithography seriously, around 1878,[1] two of his earliest prints were *lithotint* studies of the Thames. 'Limehouse' (Plate xx) was one of these, and this technique was admirably suited to the artist's passion for the more subtle moods of London's great river; nocturnal view especially. It was a technique to which he returned again as late as 1896, in the superbly melting study, 'The Thames' (Plate xx). The lithotint process consists of the application to the stone—or plate—of washes of water mixed with lithographic ink in varying strengths and proportions according to the result required. The ultimate effect is very much like that of a brush and wash drawing. Whistler also used the stump in the making of his lithographs. This instrument is in fact a paper pencil with a pointed end, the texture like that of blotting paper. It was widely used by artists and art students during the late nineteenth century, and in the early years of the present century. Its function was to help blend and soften the tones of pencilwork.[2] Whistler admirably adapted it to lithography.

But one of the most curious and baffling features of Whistler's keen and searching feeling for the medium of lithography is that he produced so few prints in colour. Only five examples are known. Four are reproduced in the present volume; the other, for technical reasons, is reproduced in black and white. (Plate xx). When one considers that Whistler frequently lived and worked in Paris,[3] and at a time when the French *avant garde*—notably Toulouse-Lautrec—were conducting the most successful experiments in colour, his lack of achievement in this

[1] It was Thomas Way who first drew Whistler's attention to the medium.

[2] Stump drawing from the antique and the live model was a common feature of art school work during this period, and I can my self recall using the stump as late as 1929 when I was a student at the Swansea School of Art.

[3] Much of his printing was done in Paris; by Belfont of the Rue Gaillon, and by Clot.

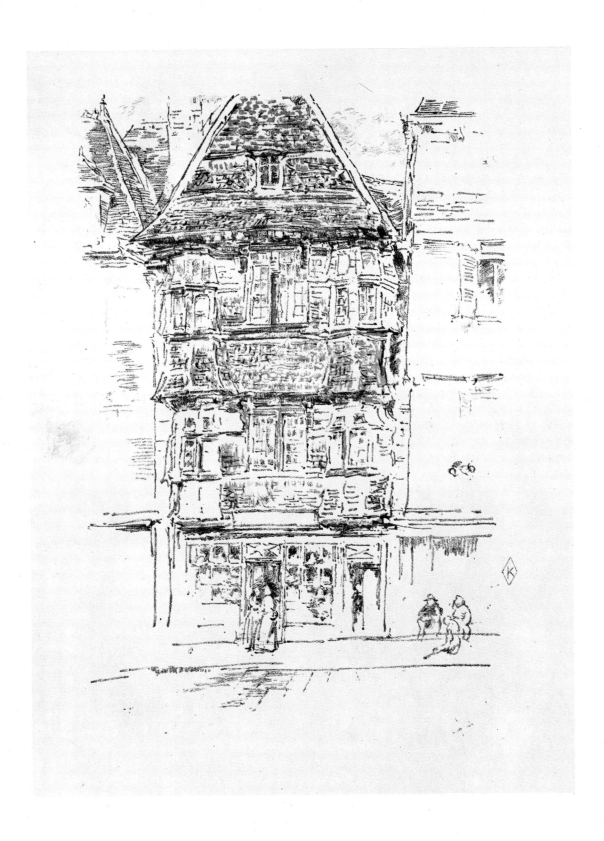

area is difficult to explain. It is perhaps best accounted for by the fact that the use of colour in relation to lithography, and the complex technical problems involved, did not suit either his natural talent or his temperament. Certainly by comparison with the colour-work of Lautrec, or more tellingly with that of Bonnard or Vuillard, his work in this field is hesitant, thin, *colourless*. Personally, I think it was a matter of temperament. The process was too involved, too long-winded for his essentially fugitive, mercurial genius. Maybe it was because he did not begin to work in colour until relatively late in life (his main experiments in this field date from around 1893). One must also remember that his wife Trixie, who died so tragically of cancer in 1896, was the one who most warmly encouraged and fostered his interest in lithography, and that after her death he lost a great deal of his enthusiasm for the medium. Between 1890 and 1896 he produced over 100 lithographs, and it could well be that any prospect for the evolution of his work in the field of colour lithography was lost forever in the tragedy of his wife's death. However, I personally take the view that so far as lithography and printmaking in general was concerned, the media offered the artist a sufficiently rich potential in black and white. After all, his work as a painter and a pastellist afforded scope enough to satisfy his need for the use of colour. Printmaking was another facet of his talent which fulfilled a different requirement; the need to find a purer vehicle even than colour; one through which he could convey a clean totality of response to his subjects, a prospect that colour would merely encumber, and even debase with its additional and complicating dimension. There is a parallel here with Odilon Redon. The two artists were contemporaries, only six years separating them in age; they werr both working in France during the heyday of colour lithography. Only twice did Redon resort to colour in his lithography. In his Journal *A Soi-meme*, and in his letters, he often refers to the medium and his views on the use of black are especially relevant. 'Black' he wrote, 'is the most essential of all colours. Nothing can debauch it . . . Lithography enjoys little esteem in France, except when it has been cheapened by the addition of colour, which produces a different result, destroying its specific qualities so that it comes to resemble a cheap coloured print.' And although Redon used black as an element of symbolism, and Whistler, I believe, as a means of purification, they shared also, one by open pronouncement, and the other by inference, a common realisation that for the artist colour is sometimes the source, not of strength, but of weakness. A dissipation of intensity, of clarity, and finally a dilution of that purity of inner meaning which is best expressed with the minimum of physical means. . . .

MERVYN LEVY
London, March 1975

PERIODICALS AND JOURNALS WHICH PUBLISHED THE LITHOGRAPHS
OF J. M. WHISTLER.

1. *The Studio*
2. *The Whirlwind*
3. *Piccadilly*
4. *Albermarle*
5. *Art Journal*
6. *L'Estampe Originale*
7. *L'Imagier*
8. *Lithography and Lithographers*
9. *Art Notes*. A project first launched in 1878. The idea was to publish prints in Editions of 100. *Limehouse* (p. xx) was the first print offered to the public—Large paper 4 guineas: small paper 2 guineas. However, the lack of subscribers caused the project to be abandoned. It was more successfully revived in 1887 when other prints were published. ().

SELECT BIBLIOGRAPHY

1. *Thomas Way: Mr Whistler's Lithographs*. First edition 1896; second edition 1905; both published by Geo. Bell & Sons, London.
2. E. R. and J. Pennell *The Life of James McNeill Whistler*. Two Vols: William Heinemann, London 1908.
3. *The Lithographs of Whistler* Kennedy & Co., New York, 1914.
4. Catalogue of an Exhibition of Etchings Drypoints & Lithographs by James McNeill Whistler. With an Introduction and Notes by Denys Sutton. P & D Colnaghi & Co, 16 November–10 December 1971.
5. The Catalogues of Frits Lugt.
6. *Whistler Journal*. E. R. and J. Pennell. Philadelphia, 1921.
7. *Nocturne*. The Art of James McNeill Whistler. *Country Life*, London, 1963.

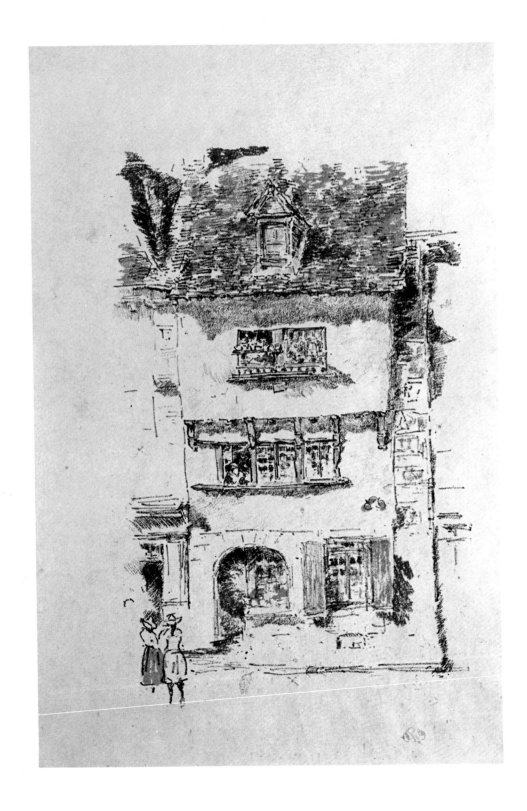

Measurements, where known, are given in centimetres and inches, height first. The size is that of the image; not the paper. The use of the name 'Way' in full followed by a figure refers to the numbering used by Thomas Way in his original catalogue. The use of the letter 'W' followed by a figure denotes the number of proofs taken by Way. Many stones were later reprinted by Frederick Goulding,[1] and these are listed as 'Reprinted by Goulding'. On the question of reprintings by Goulding, Way records that after Whistler's death he (Goulding) made limited editions of certain subjects from stones that had been held by the artist's solicitors following the quarrel between Whistler and the Way family in 1896. These editions were limited to 25 proofs. However, in many cases it is not possible to record how many prints were made of particular subjects, and a number of dates are also a matter of conjecture, although stylistic qualities make this a more probable hazard to undertake.

Many lithographs were reprinted for publications such as *Studio, Piccadilly, Art Notes*, and *The Whirlwind*. These are referred to in the notes and a list of all the publications involved is given in a supplementary Bibliography. Naturally these reprintings, commercially speaking, are of considerably less value than the original, often small, editions.

So diverse and varied were the papers used by Whistler, Way, and others concerned with the printing of the artist's stones, that it is impossible to do more than state here that these papers range from laid and smooth woven papers, to Japans, Van Gelder Zonen, and variously water-marked papers among which the ciphers *D & C Blauw, Pro Patria, O.W.P & A.C.L.*, and *Brittania* figure prominently.

The butterfly signature is usually signed in the stone, and occassionally added in pencil. However, further details of the papers used are given in the introductions by Thomas Way to the Catalogues of 1896 and 1905, both of which are reprinted in this volume. Way notes for instance that many proofs were taken on 'good ordinary white paper', and that Whistler himself was particularly fond of Dutch and old Chinese papers. On the question of distinguishing the Way printings from those of Goulding, this is never an easy matter. Some of the Way proofs are stamped *T. Way. Imp. London*, or *Imp. T. Way. London*. A great many carry no stamp. This applies to most of the Way lithographs in the collection of the British Museum, many of which were given to that institution by Way. Some prints however bear the Way stamp enclosed within a square border; others, those reprinted by Goulding, carry the same stamp enclosed within a round border. But there are no conclusive rules of thumb on this issue.

In some instances the quality of reproduction is by no means as good as the author and publisher would have wished, but this is inevitable since some of the works are of such rarity and small printings that it has been impossible to locate original examples from which to make the reproductions. In the case of Way 160, *Two Sketches* (25 × 17cm.—10 × 7in.) it has been found impossible to locate any impression for reproduction. The print is of the greatest rarity, and quite possibly unique. Way notes that the sketch top left is possibly a portrait of Chas. A. Howell, and that the print was probably a final proof taken from a transfer paper.

[1] Goulding first met Whistler in 1859 and later did much of his printing. Whistler called him 'the best printer in England'. See Vol. I, page 92, Pennell's *Life of James McNeill Whistler.*

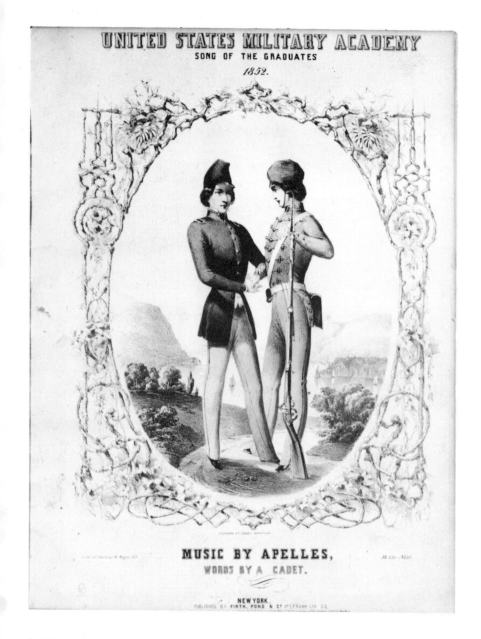

1 SONG OF THE GRADUATES
Lithograph. 1852.
Design for a Music Cover. 2.5 × 26cm. (13⅜ × 10¼in.)
The earliest known lithograph by Whistler, made while the artist was a Cadet at the Military Academy at West Point. John Sandberg writes: 'Though the final design may owe something to the hand of the professional lithographer who printed the sheet, Whistler deserves credit for the original drawing which represents a finished, polished version of his West Point sketching style'. I think one can be more conclusive than this. A careful comparison between the stylistic qualities which distinguish the drawing of the Music Cover, and the pen drawing, 'A Man Dispensing Alms' (*The Art Quarterly*, Vol. XXIV, 1966, Pages 45–58) also made while Whistler was at the Military Academy, suggests no reason why he cannot be credited with the complete

drawing of the stone. A professional lithographer working at second-hand from someone else's drawing is unlikely to have achieved such a notable degree of freshness, or to have worked with such finished and polished finesse.

Many years later, in 1888, J.L. Black, a former cadet and class-mate wrote from South Carolina to Whistler: (This letter is now in the Birnie-Philip Collection, University of Glasgow.) 'I have today but one of your pieces . . . It was lithographed as a frontispiece to a cadet class song, and if my memory serves me right was drawn by you in my room—one of the figures was (little Aleck) E. P. Alexander, who became famous in the War of Rebellion . . . the other was your own likeness. . . .'
The figure on the left is that of Whistler.

Art Institute of Chicago, Walter S. Brewster Collection

2 A MAN DISPENSING ALMS
Pen and Ink Drawing. *c.* 1852–54.
55 × 74.4cm. (21¾ × 29½in.)
This drawing was copied from an unidentified original, although the Pennells in their life of Whistler quote Colonel Larned of West Point as writing to them: 'The pen and ink drawing must have been his own interpretation of a coloured print'. This statement is further qualified by the artist's biographers who suggest that the print was probably a lithograph by Nash or Haghe, and that Whistler's interpretation has in it already the origins of the handling of his etchings. (*The Life of James McNeill Whistler*, 1908. Vol. 1, Page 32.)

West Point Museum Collections, United States Military Academy

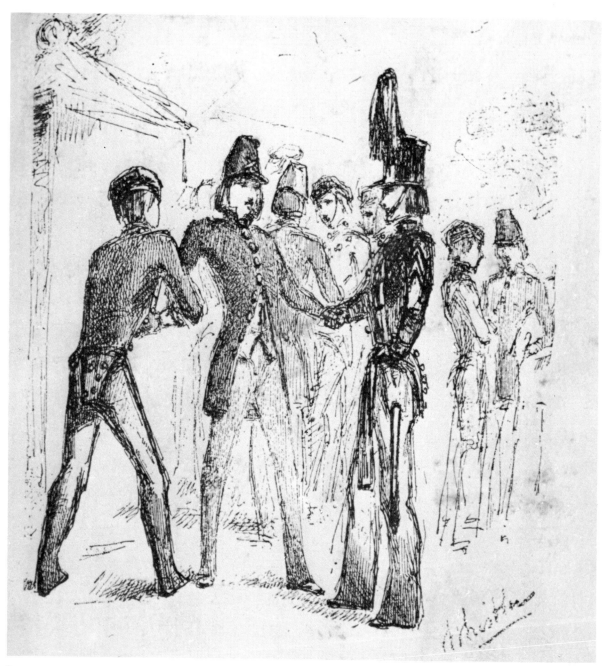

2a PEN DRAWING.

1852

17×16.1 cm. ($6\frac{3}{4} \times 6\frac{3}{8}$in.)

One of a group of drawings made at West Point. It shows, not only the germinal idea for the lithograph, *Song of the Graduates*, but reveals to a remarkable degree the main elements of Whistler's graphic work: the delicate, fragile, and exquisitely sensitive quality of vision and style, that was later to suffuse and distinguish the whole of his *oeuvre* as a printmaker.

West Point Museum Collections, United States Military Academy

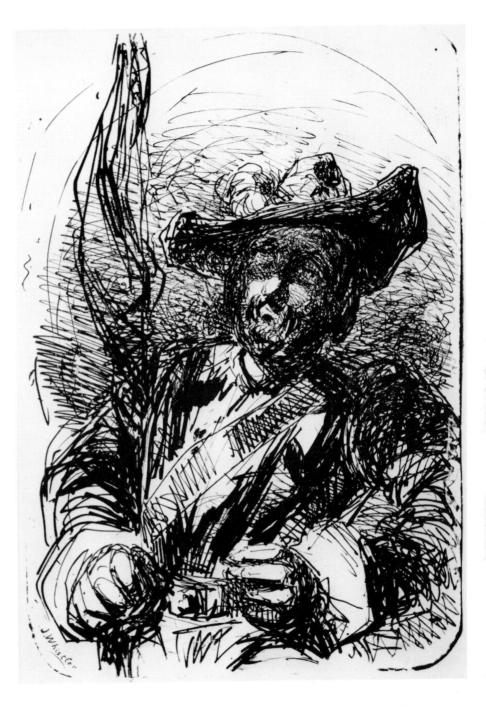

3 THE STANDARD BEARER
Lithograph. 1855.
20 × 14.2cm. (8 × 5⅝in.)
Signed in the stone 'J. Whistler'; the way in which the artist usually signed his early and youthful works. On the reverse of the print are two inscriptions in pencil:
(Centre) 'J. Whistler, fecit.
Baltimore. 1855 17 July
to Frank B. Mayer.'

and (Lower left corner) 'F. M. from J. Whistler
Balto. July 17 1855.'
Both these inscriptions are in the handwriting of Francis Blackwell Mayer, step-father of the first owner of this print, a painter who spent most of his working life in Baltimore and Annapolis. The lithograph was later found in a scrapbook of Mayer's sketches.

Library of Congress

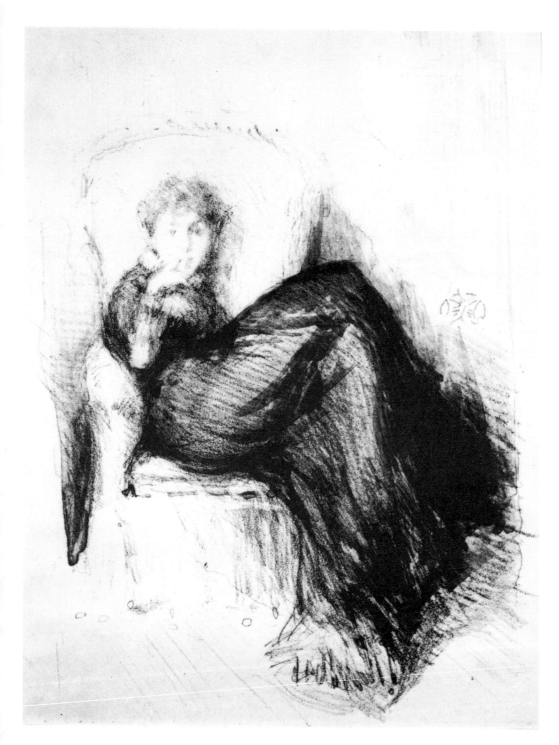

4 STUDY: MAUDE SEATED
Lithograph. 1878.
Signed with the Butterfly. 26.5 × 18.4cm. (10½ × 7¼in.)
Way: 131. Way records 10 trial proofs only.

British Museum

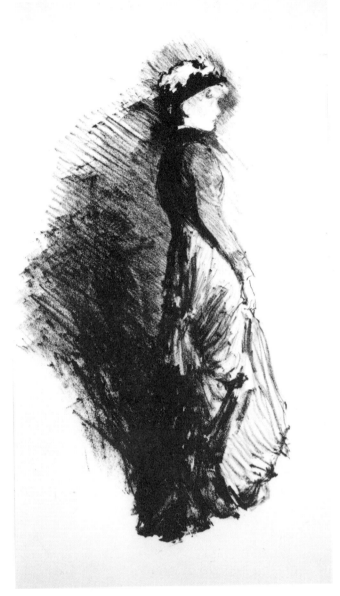

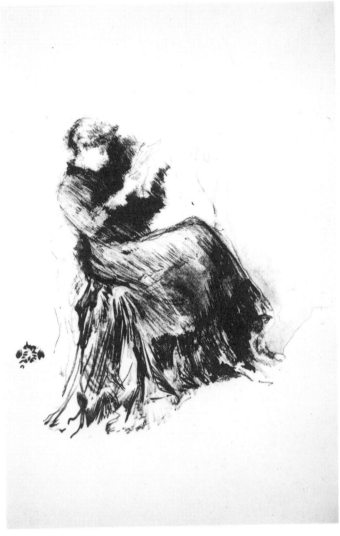

5 STUDY: STANDING FIGURE
Lithograph. 1878.
27.3 × 15cm. (10¾ × 6in.)
Way: 1. W: 8

British Museum

6 STUDY: SEATED FIGURE
Lithotint. 1878.
Signed with the Butterfly. 25.5 × 24cm. (10 × 9¼in.)
Way: 2. W: 12.

British Museum

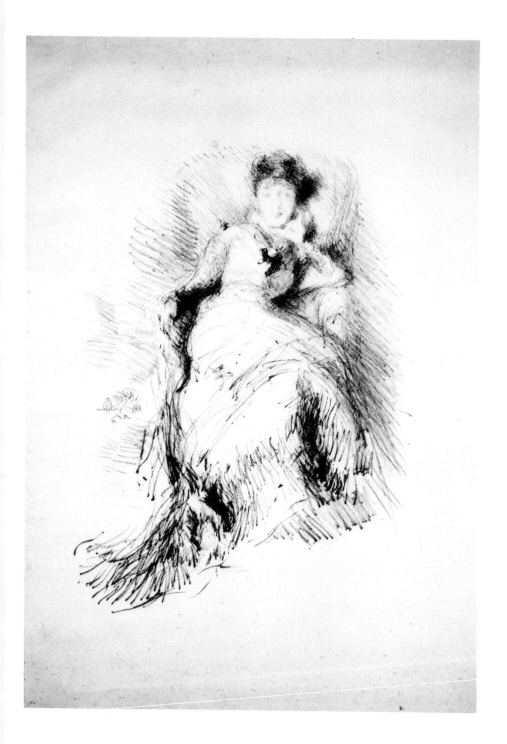

7 STUDY: SEATED FIGURE
Lithograph. 1878.
Signed with the Butterfly. 26.5 × 20cm. (10½ × 8in.)
Possibly a portrait of Sarah Bernhardt.
Way: 3. W: 12.

British Museum

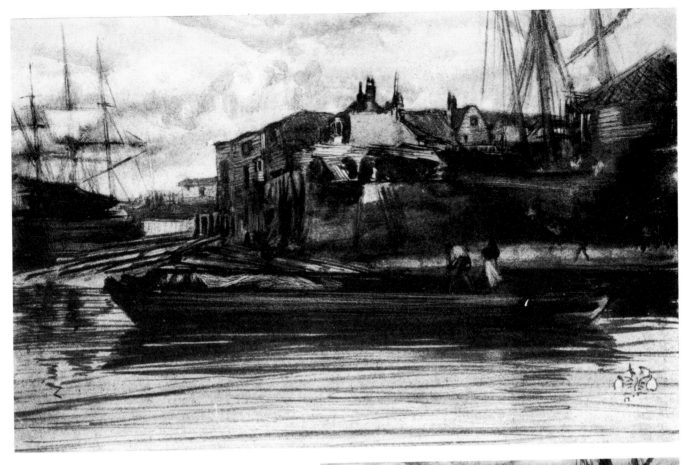

8 LIMEHOUSE
Lithotint. 1878. Second and finished state.
Signed with the Butterfly. 17 × 26.4cm. (6¾ × 10⅜in.)
Way: 4. W: 35.
Published later in *Art Notes*.
Whistler's use of the lithotint technique, the employment of
washes of ink followed by scraping, was especially suitable for
river, and 'nocturne' subjects.
Limehouse was one of the few of his lithographs to be published,
privately in 1878, as one of the proposed group of *Art Notes*. See
Way's Introduction.

British Museum

9 LIMEHOUSE
Lithotint. 1878. First State of 8.
Signed with the Butterfly. 17 × 26.4cm. (6¾ × 10⅜in.)
Only a few trial proofs printed. In the finished state the sky has
been lightened, and the general balance of tone values is more
subtle.
Way: 4A.

British Museum

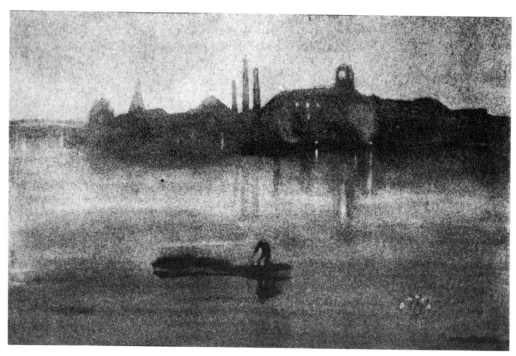

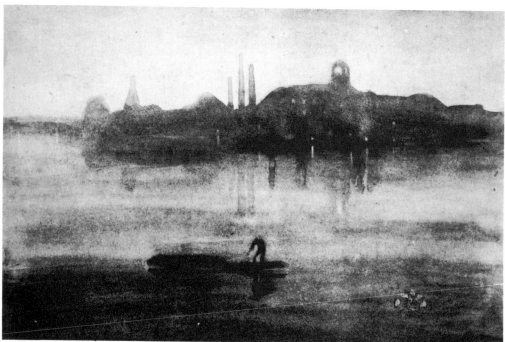

10 & 11 NOCTURNE: THE RIVER AT BATTERSEA
Lithotint. 1878.
Signed with the Butterfly. 17 × 25.7cm. (6¾ × 10⅛in.)
Two States: In the final state (II) the sky has been lightened.
Way: 5. W: 100.
Published in *Art Notes*.

British Museum

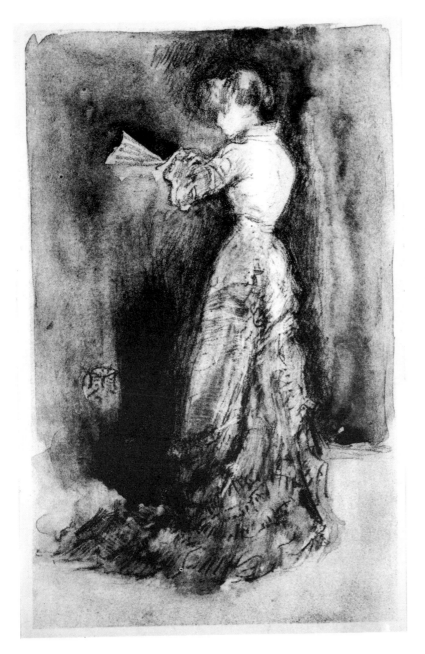

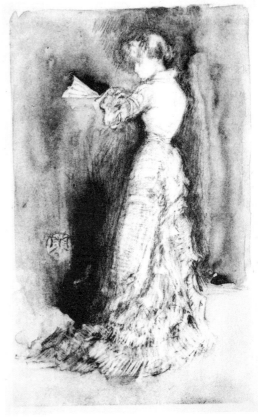

12 THE TOILET
Lithotint. 1878.
Signed with the Butterfly. 25.7 × 16.5cm. (10⅛ × 6½in.)
Drawn for *Piccadilly* and published in July 1878.
Way: 6.

British Museum

13 THE TOILET
Lithotint. 1878.
First state of 12 and before the darkening of the tones.
About 12 copies only.
Way: 6A.

British Museum

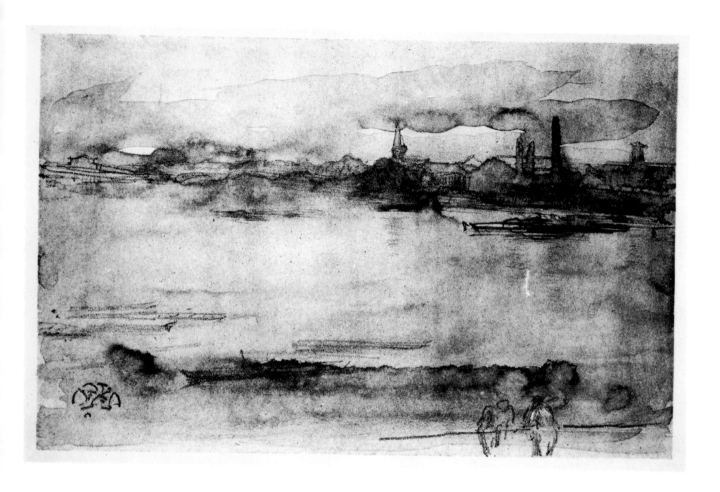

14 EARLY MORNING
Lithotint. 1878.
Signed with the Butterfly. 16.5 × 26cm. (6¼ × 10¼in.)
First State.
Way: 7A.

15, 16 and **17**, successive states of 14. All recorded as Way: 7. The first state, of which about 12 copies were printed, was reworked in two further states (15 and 16). In these the artist scraped away the unnecessary darks. Only two or three proofs of these states were pulled. When the stone was finally completed a number of copies were taken, some of which were exhibited at the Fine Art Society's Gallery in 1895. Eventually, as more prints were taken, the old work began to re-appear (17). The drawing was again scraped. About 50 copies were finally pulled. *Early Morning* was intended for, but never published by *Piccadilly*.

British Museum

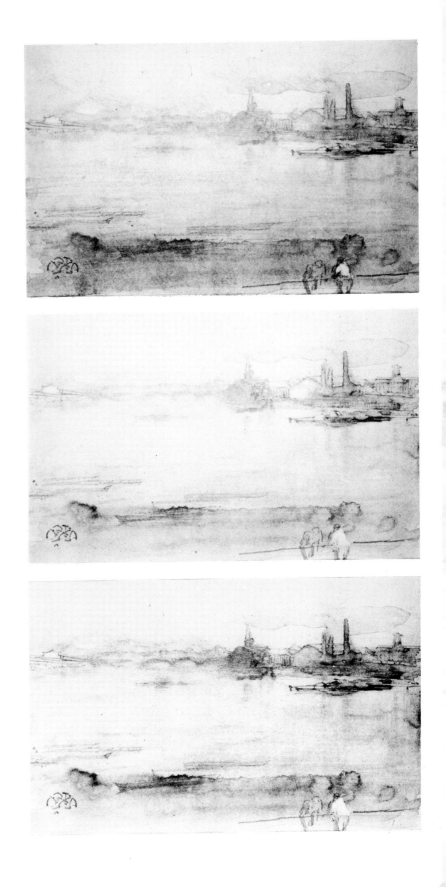

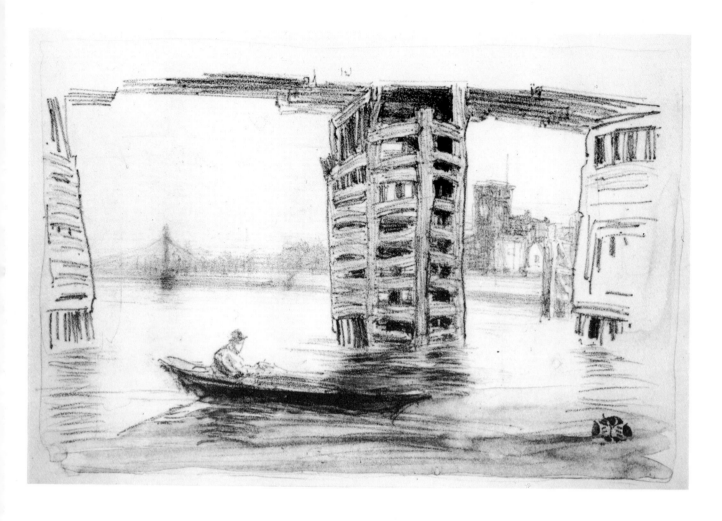

18 THE BROAD BRIDGE
Lithotint. 1878.
Signed with the Butterfly. 18.2 × 28cm. (7¼ × 11in.)
The subject depicts three wooden piers of old Battersea Bridge
seen at low tide. Drawn for and published by *Piccadilly*.
Way: 8. W: 12. A few very fine prints on Japanese paper.

British Museum

19 THE TALL BRIDGE
Lithotint. 1878.
Signed with the Butterfly. 27.8 × 18cm. (10⅞ × 7⅛in.)
Drawn for *Piccadilly* on the same stone as No. 18 (*The Broad
Bridge*). Some prints were taken, but not published. Only a few
fine proofs on Japanese paper exist (or did exist).
Way: 9. W: 12.
This, and *The Broad Bridge* are recorded as having been printed
in brown.

British Museum

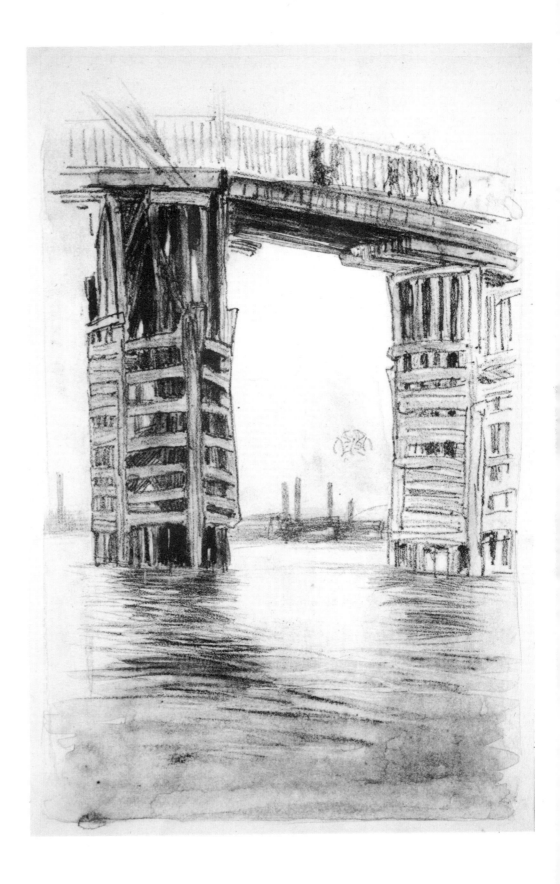

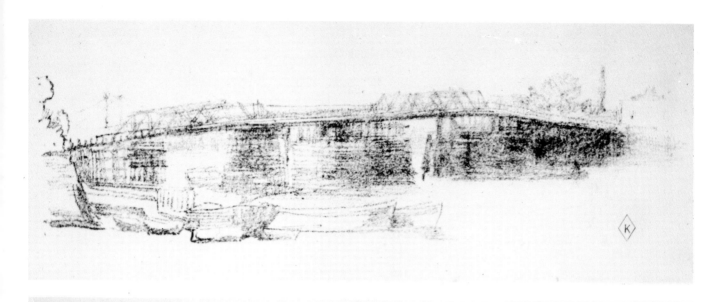

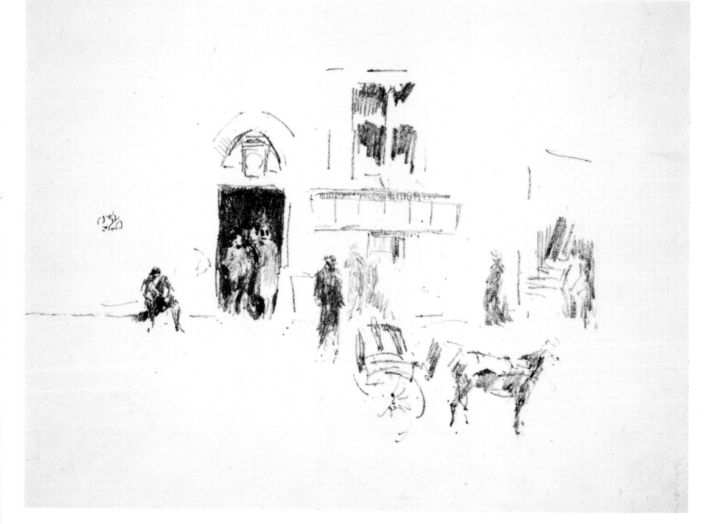

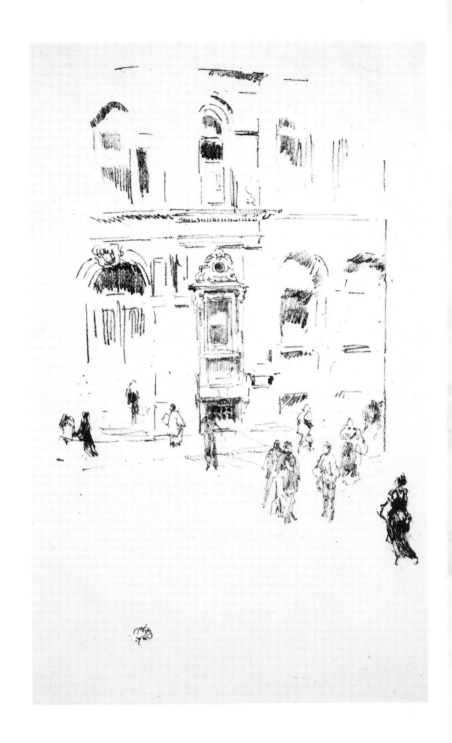

20 OLD BATTERSEA BRIDGE
No. 2 Lithograph. 1878.
No Signature. 6.4 × 26.3cm. (2½ × 10⅜in.)
Way: 132. 5 or 6 prints only.

British Museum

21 GAIETY STAGE DOOR
Lithograph. 1879.
Signed with the Butterfly. 12.4 × 19.4cm. (4⅞ × 7⅝in.)
Published in *Art Notes*.
Way: 10. W: 100.

British Museum

22 VICTORIA CLUB
Lithograph. 1879.
Signed with the Butterfly. 20.3 × 13.8cm. (8 × 5⅜in.)
Published in *Art Notes*.
Way: 11. W: 100.

British Museum

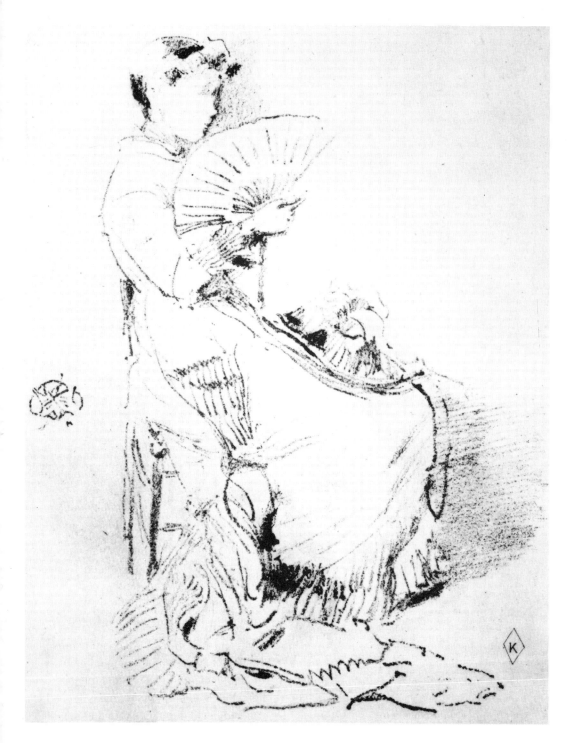

23 THE FAN
Lithograph. 1879.
Signed with the Butterfly. 20.5 × 15.8cm. (8⅛ × 6¼in.)
Way: 14. W: 10.

British Museum

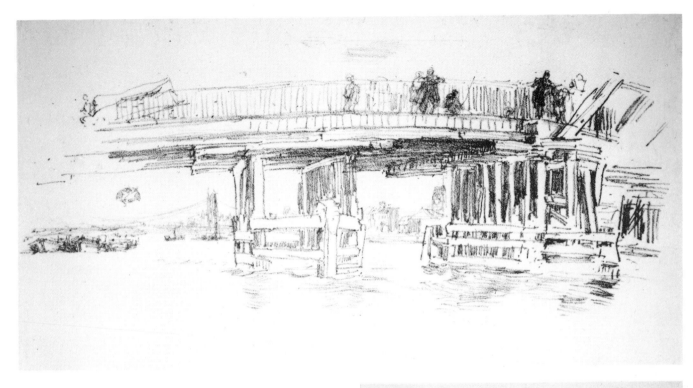

24 OLD BATTERSEA BRIDGE
Lithograph. 1879.
Signed with the Butterfly. 14 × 32.9cm. (5½ × 13in.)
Published in *Art Notes*.
Way: 12. W: 100.

British Museum

25 LADY READING
Lithograph. 1879.
Signed with the Butterfly. 15.2 × 12.6cm. (6 × 5in.)
Published in *Art Notes*.
Way: 13. W: 100.

British Museum

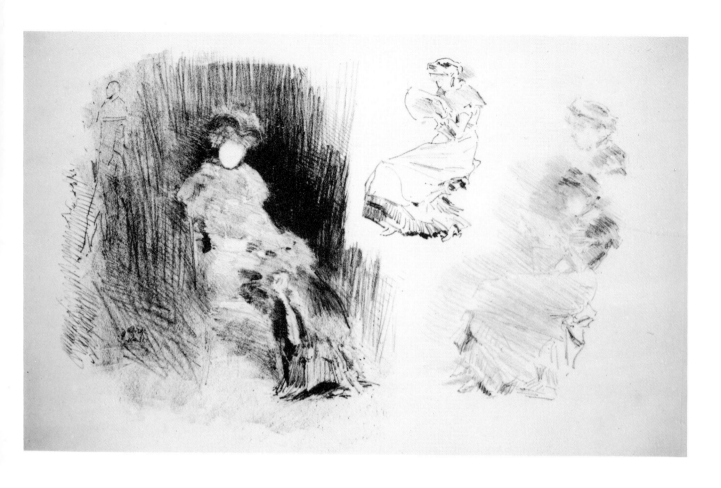

26 GIRL READING AND OTHER STUDIES
Lithograph. *c.* 1879.
Unsigned. 24 × 35.5cm. (9¼ × 14¼in.)
The first idea for No. 25 (LADY READING) appears in two versions on this stone.
A few proofs on Japan were taken before the stone was cleaned to leave only the finished state of No: 25.
Way: 13A. W: 15.

British Museum

27 STUDY: CLASSICAL FIGURE
Lithograph. 1879.
Signed with the Butterfly. 26 × 16cm. (10¼ × 6⅛in.)
Drawn on a tinted background, the lights scraped.
Way: 15. W: 10.

British Museum

28 A DRAWING ON TRANSFER PAPER OF MISS FRANKLIN AND
CHARLES AUGUSTUS HOWELL
c. 1880–84. 7.5 × 10.1cm. (2⅞ × 4in.) Never printed. See author's
introduction for notes on Whistler's use of transfer paper.
Not recorded in Way.

British Museum

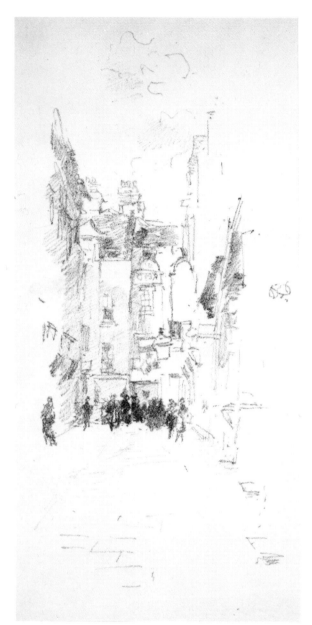

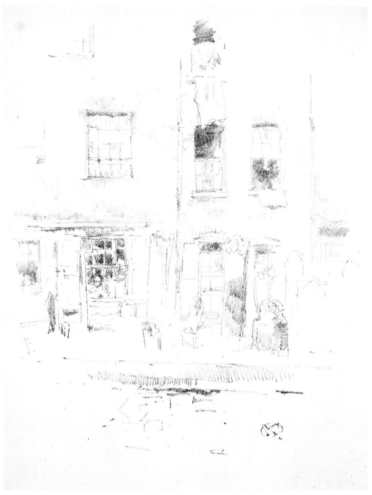

29 LITTLE COURT, CLOTH FAIR
Lithograph. 1887.
Signed with the Butterfly. 19 × 8.5cm. (7½ × 3⅜in.)
Way: 18. W: 12.

British Museum

30 CHURCHYARD
Lithograph. 1887.
Signed with the Butterfly. 21 × 17cm. (8¼ × 6¾in.)
This subject portrays the gravestones in St Bartholomew's, and
shows the backs of the old buildings in the Cloth Fair.
Way: 17. W: 10.

British Museum

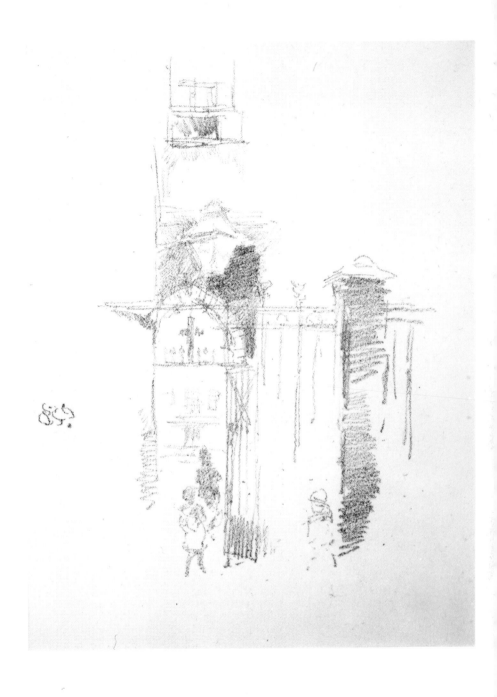

31 ENTRANCE GATE
Lithograph. 1887.
Signed with the Butterfly. 14.9 × 12cm. (5⅞ × 4¾in.)
This subject portrays the entrance to the Churchyard of St Bartholomew's the Great, London.
Way: 16. W: 12.

British Museum

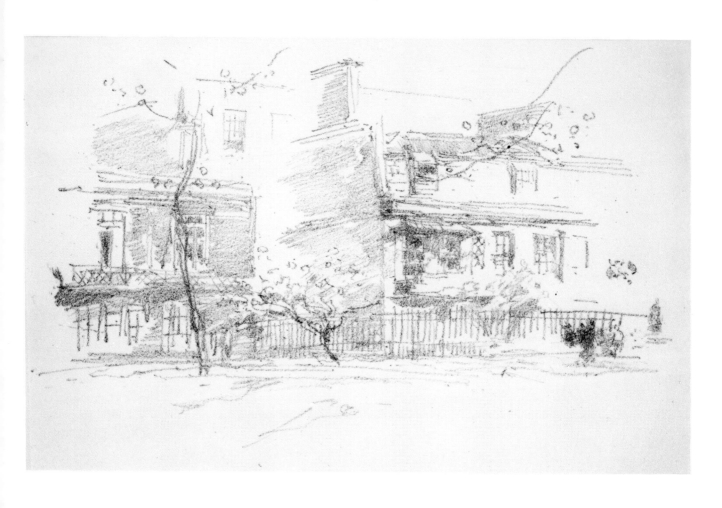

32 LINDSAY ROW, CHELSEA
Lithograph. 1888.
Signed with the Butterfly. 12.6 × 20.2cm. (5 × 8in.)
Way: 19. W: 14.
Reprinted by Goulding.

British Museum

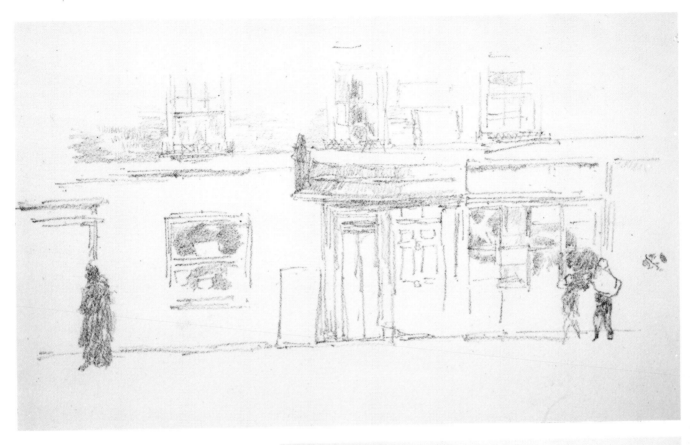

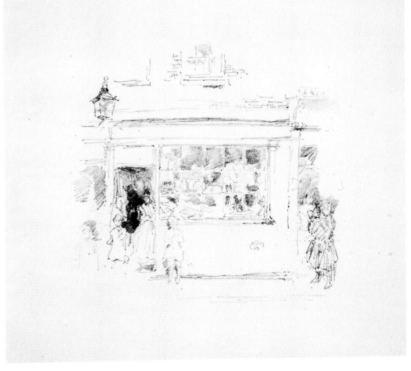

33 CHELSEA SHOPS
Lithograph. 1888.
Signed with the Butterfly. 9.5 × 19.3cm. (3¾ × 7⅝in.)
Way: 20. W: 17.
Reprinted by Goulding.

British Museum

34 DRURY LANE RAGS
Lithograph. 1888.
Signed with the Butterfly. 14.9 × 16.2cm. (5⅞ × 6⅜in.)
Way: 21. W: 14.

British Museum

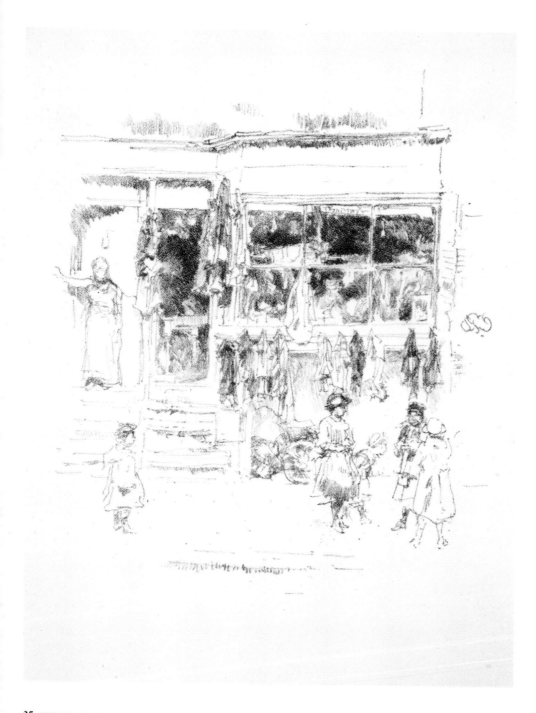

35 CHELSEA RAGS
Lithograph. 1888.
Signed with the Butterfly. 18 × 15.9cm. (7⅛ × 6¼in.)
A shop in Milman's Row.
Published in *Albermarle*.
Way: 22. W: 13.
Reprinted by Goulding.

British Museum

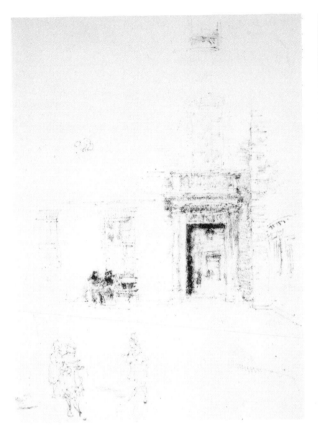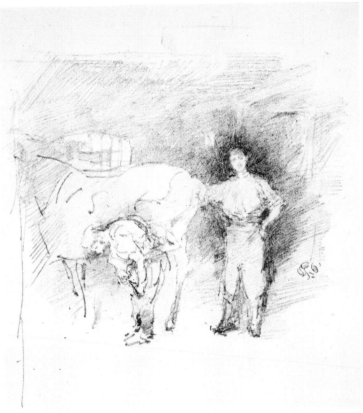

36 COURTYARD, CHELSEA HOSPITAL
Lithograph. 1888.
Signed with the Butterfly. 21.5 × 15.5cm. (8½ × 6⅛in.)
Way: 23. W: 6.

British Museum

37 THE FARRIERS
Lithograph. 1888.
Signed with the Butterfly. 20 × 17.8cm. (7¾ × 7in.)
Way: 24. W: 6.

British Museum

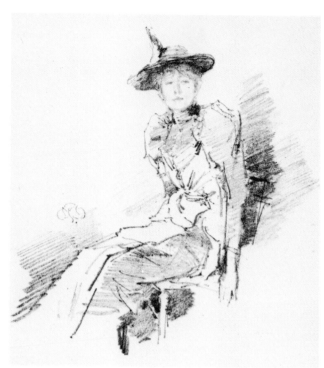

38 THE WINGED HAT
Lithograph. 1890.
Signed with the Butterfly. 17.8 × 17cm. ($\dot{7}$ × 6$\frac{3}{4}$in.)
Way: 25. W: 22. Reprinted by Goulding.
Published in the *Whirlwind*.

P & D Colnaghi & Co

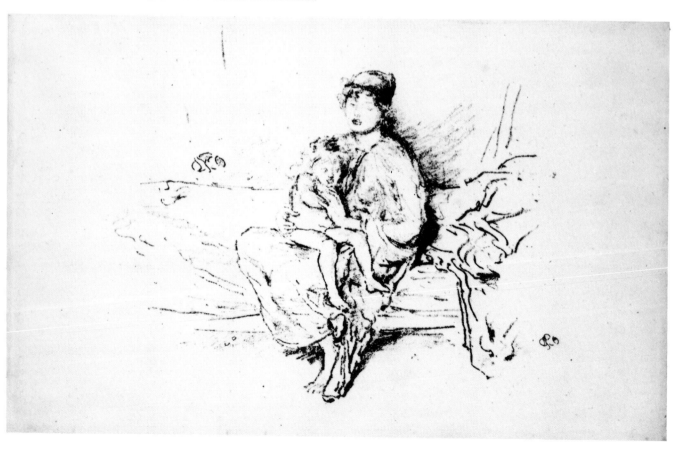

40 GANTS DE SUÈDE
Lithograph. 1890.
Signed with the Butterfly. 21.5 × 10.1cm. (8¼ × 4in.)
The subject is Ethel Birnie Philip.
Way: 26. W: 28. Reprinted by Goulding.
Published in *The Studio*. Studio Stamp.

British Museum

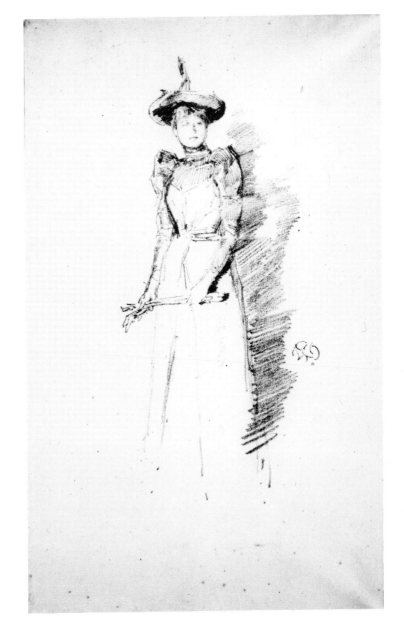

39 MOTHER AND CHILD: No 2
Lithograph. 1890.
Signed with the Butterfly. 15.8 × 20cm. (6¼ × 7¾in.)
Way: 102. W: 20.
Drawn on transfer paper in 1890 but not printed until some
years later, most probably in 1895. Whistler made at least six
drawings of this subject on transfer paper, each a variation of
the main theme. They were only transferred to stone at a later
date, and were generally considered unsuccessful by the artist.
This was due to the problem of successfully transferring to
stone, drawings on transfer paper that had lain around for
some years. In most cases, and especially in the case of *Mother
and Child* No 3 (Plate 142), this was a messy and unsatisfactory
process. Until this point in time only five versions of the subject
have been known to exist. However, Glasgow University pos-
sess a photograph of a drawing, or a lithograph, which is listed
in their catalogue as *Mother and Child* No. 6 (Plate 143). Since
it is impossible to tell from the photograph precisely what this
is, the author's conclusion is that it is most probably a photo-
graph of a drawing on transfer paper never transferred to the
stone. The fact that this study alone of the series is unsigned
with the Butterfly, would seem to lend weight to the view that
it is a preliminary study. It can be compared with *Mother and
Child* No. 4 (Plate 141) though it was most probably drawn ear-
lier than 1895.

British Museum

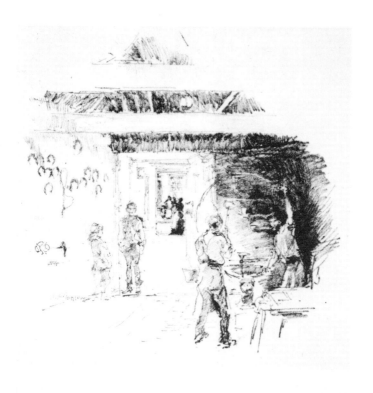

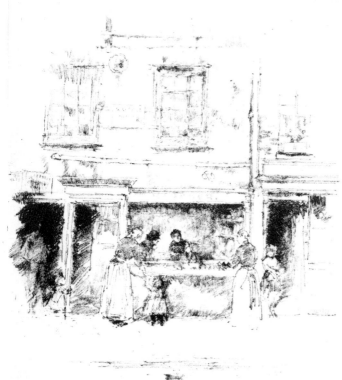

41 THE TYRESMITH
Lithograph. 1890.
Signed with the Butterfly. 16 × 17.7cm. (6½ × 7in.)
Way: 27. W: 8. Reprinted by Goulding.
Published in the *Whirlwind*.

British Museum

42 MAUNDER'S FISH SHOP, CHELSEA
Lithograph. 1890.
Signed with the Butterfly. 19 × 17.1cm. (7½ × 6¾in.)
Way: 28. W: 28. Reprinted by Goulding.
Published in the *Whirlwind*.

British Museum

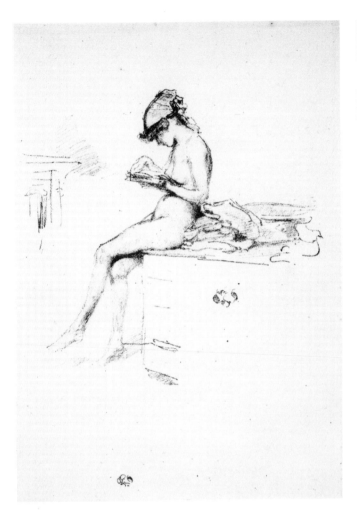 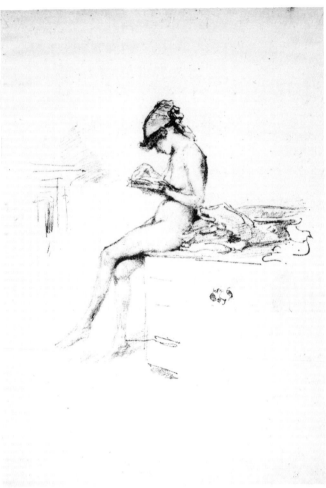

43 and **44** THE LITTLE MODEL RESTING
Lithograph. 1890.
44 Signed with the Butterfly. 16.8 × 17.7cm. (6⅝ × 7in.)
Way: 29. W: 28. Reprinted by Goulding.
43 is presumably a second state of 44, the only apparent differ-
ence being the addition of a second butterfly signature.

British Museum

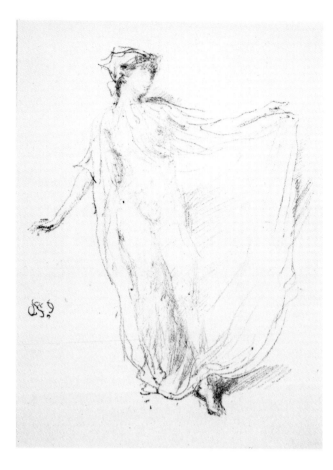

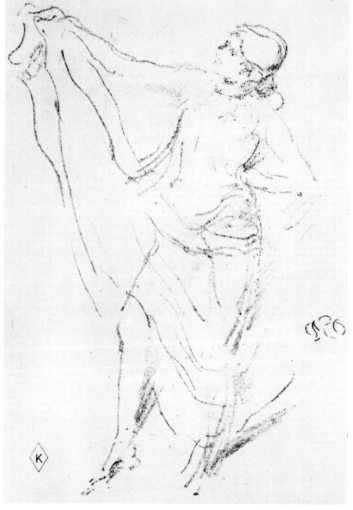

45 THE DANCING GIRL
Lithograph. 1890.
Signed with the Butterfly. 17.7 × 14.5cm. (7⅛ × 5¼in.)
Way: 30. W: 32. Reprinted by Goulding.

British Museum

46 DRAPED MODEL DANCING
Lithograph. *c.* 1890.
Signed with the Butterfly. 17.6 × 11.4cm. (7 × 4½in.)
Not recorded in Way.

British Museum

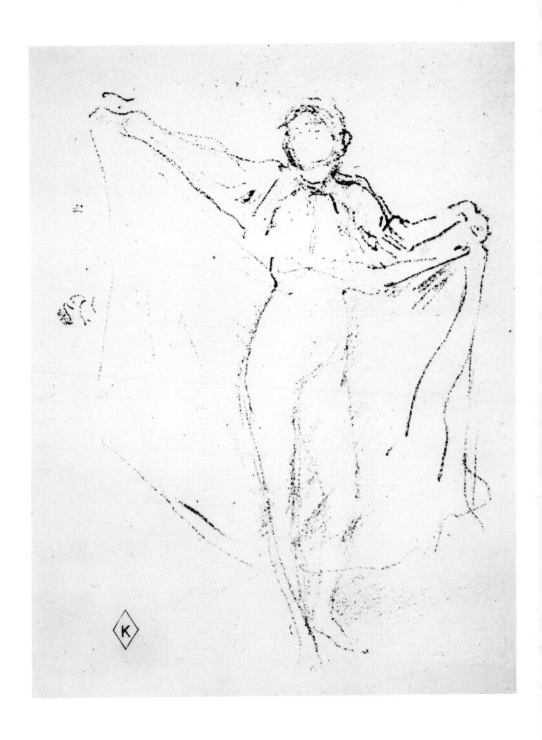

47 LA DANSEUSE: A study of the Nude
c. 1890.
Signed with the Butterfly. 17 × 12.5cm. (6¾ × 4⅞in.)
Way: 148. Printed in Paris.

British Museum

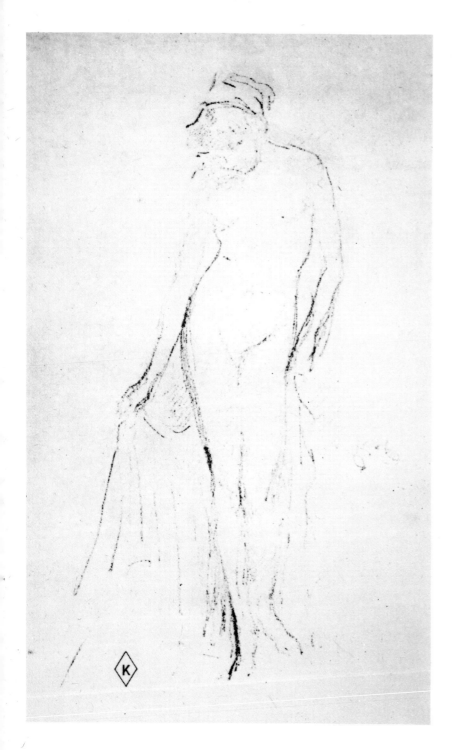

48 NUDE MODEL STANDING
Lithograph. *c.* 1890.
Signed with the Butterfly. 18.8 × 10.7cm. (7⅜ × 4¼in.)
Way: 154. Printed in Paris.

British Museum

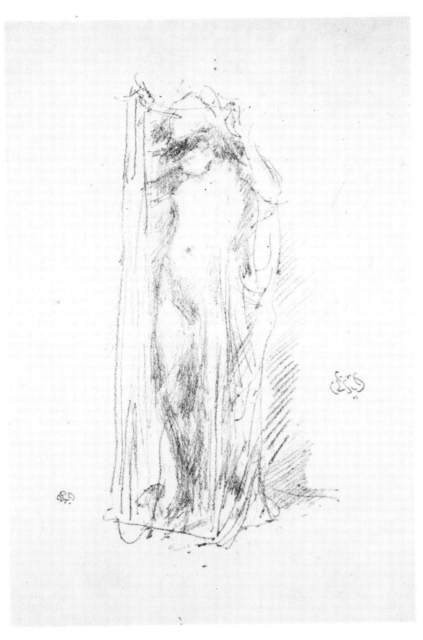

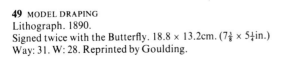

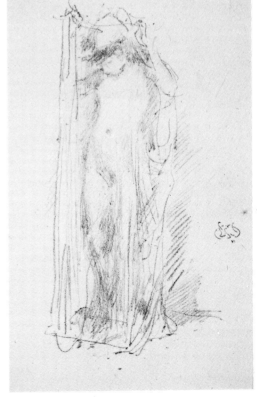

49 MODEL DRAPING
Lithograph. 1890.
Signed twice with the Butterfly. 18.8 × 13.2cm. ($7\frac{3}{8}$ × $5\frac{1}{4}$in.)
Way: 31. W: 28. Reprinted by Goulding.

50 MODEL DRAPING
Lithograph 1890. 18.8 × 13.2cm. ($7\frac{3}{8}$ × $5\frac{1}{4}$in.)
Presumably a first state of 49, signed only once, and before the
tone values had been strengthened.
Way: 31.

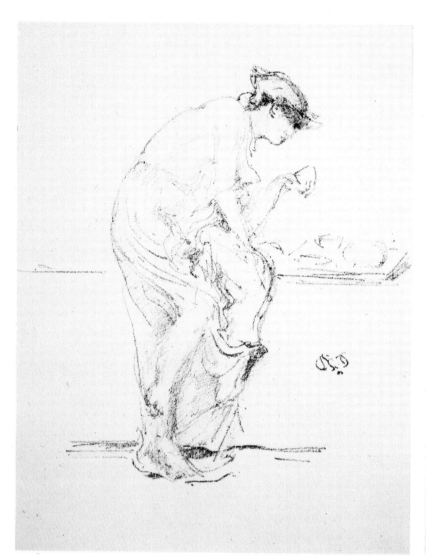

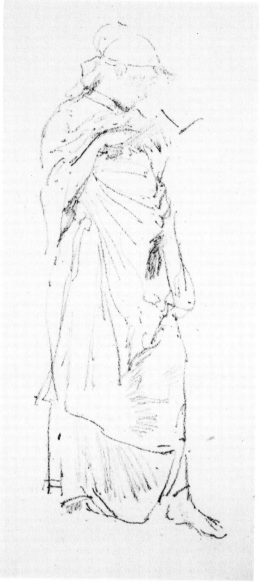

51 THE HOROSCOPE
Lithograph. 1890.
Signed with the Butterfly. 16 × 15.7cm. (6⅜ × 6¼in.)
Way: 32. W: 6. Reprinted by Goulding.

British Museum

52 THE NOVEL: STUDY OF A GIRL READING
Lithograph. 1890.
Unsigned. 20 × 7.7cm. (7¾ × 3⅜in.)
Way: 33. W: 6. Reprinted by Goulding.

British Museum

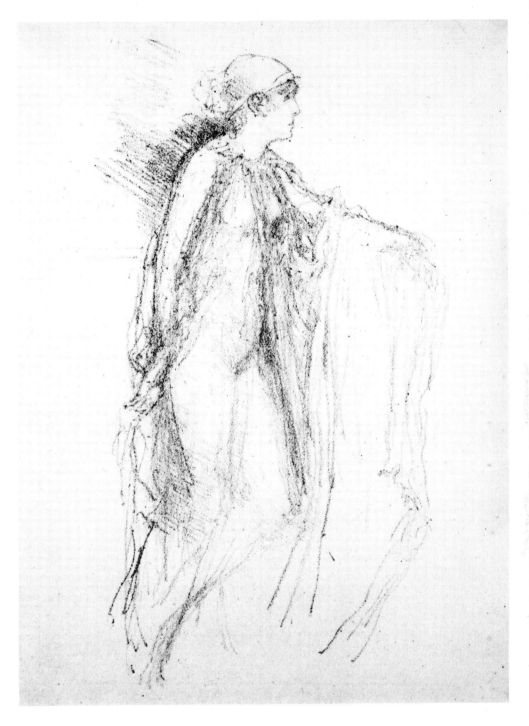

53 THE CAP
Lithograph. *c.* 1890.
No Signature. 20.2 × 14cm. (8 × 5½in.)
Way: 158. Printed in Paris.
Shown at the Whistler Memorial Exhibition, Boston, 1904.

British Museum

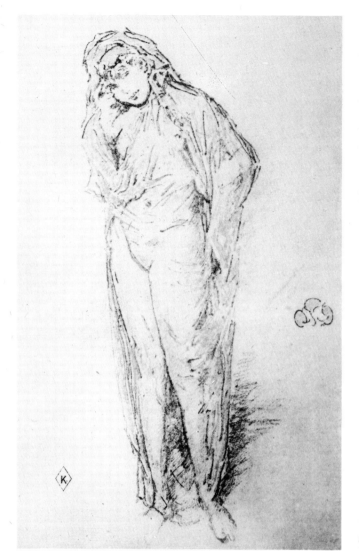

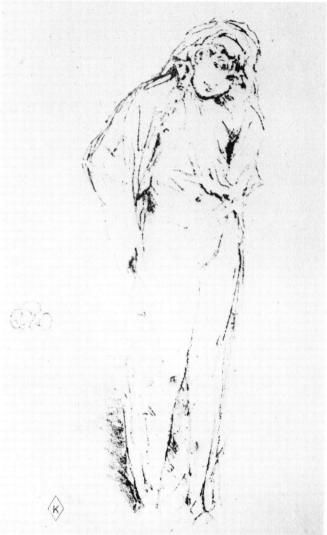

54 DRAPED FIGURE STANDING
Lithograph in colours. *c.* 1890–95.
Signed with the Butterfly. 23 × 10.7cm. (8⅞ × 4¼in.)
Way: 155. Printed in Paris.
Way notes two different colour states of this print, as well as a printing in Bistre.
(a) Blue, red and yellow.
(b) Gray, flesh, red and green.

British Museum

55 NUDE MODEL WITH HEAD BENT
Lithograph. *c.* 1890–95.
Signed with the Butterfly. 21.5 × 8.2cm. (8½ × 3¼in.)
The subject is that of 54 in reverse.
Not recorded in Way.

British Museum

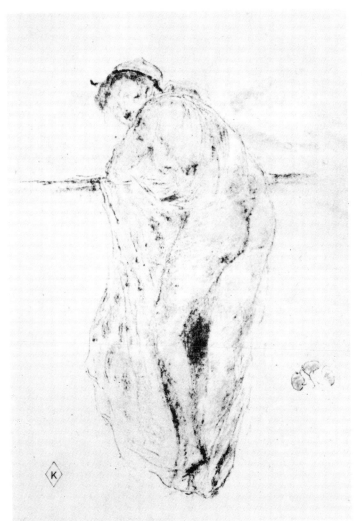

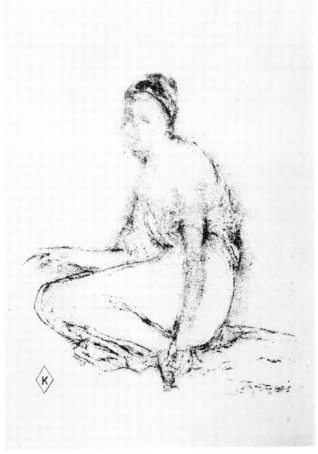

56 NUDE MODEL, BACK VIEW
Lithograph. *c.* 1890–95.
Signed with the Butterfly. 18.5 × 13.8cm. (7¼ × 5⅜in.)
Not recorded in Way. The first impression of this subject was
taken in colour.

British Museum

57 MODEL SEATED ON FLOOR
Lithograph. *c.* 1890–95.
Unsigned. 12.6 × 11.5cm. (5 × 4½in.)
Unrecorded in Way.

British Museum

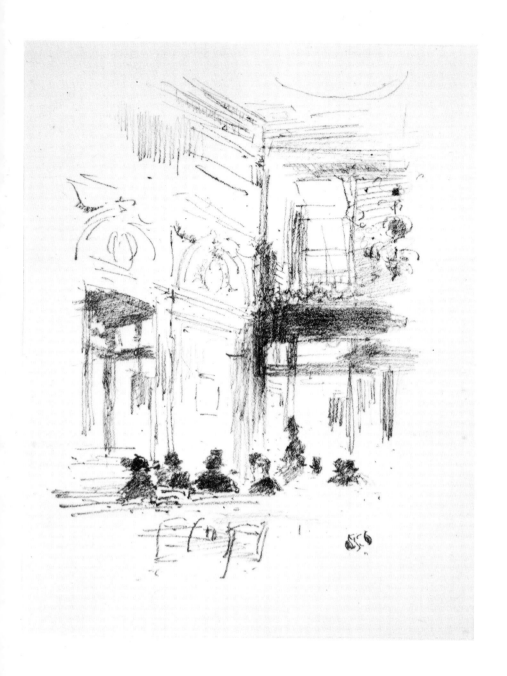

58 GATTI'S
Lithograph. 1890.
Interior of the restaurant in the Strand.
Signed with the Butterfly. 17 × 12.6cm. (6¼ × 5in.)
Way: 34. W: 4.

British Museum

59 SKETCH: GRAND RUE DIEPPE
Lithograph. 1891.
No Signature. 7.6 × 12.6cm. (3 × 5in.)
Way: 146.
Way notes that the same sheet includes a slight sketch of an
interior with figures. This print was an experiment made upon
coarse-grained transfer paper, and not transferred to the stone
until 1904, the year following the artist's death (1903).

British Museum

60 HOTEL COLBERT, WINDOWS
Lithograph. 1891.
Signed with the Butterfly. 17.3 × 12.6cm. (6⅚ × 5in.)
Way: 35. W: 8.

British Museum

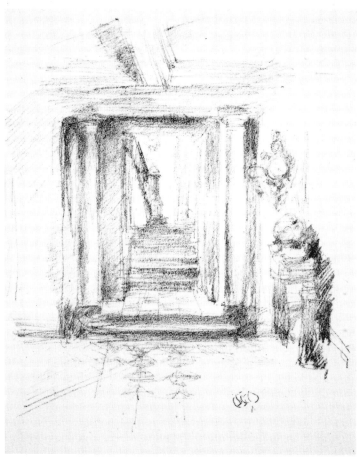

61 COCKS AND HENS, HOTEL COLBERT
Lithograph. 1891.
Signed with the Butterfly. 19.3 × 14.2cm. (7⅝ × 5⅝in.)
Way: 36. W: 8.

British Museum

62 STAIRCASE
Lithograph. 1891.
Signed with the Butterfly. 18.5 × 16cm. (7¼ × 6⅜in.)
Way: 37. W: 4.

British Museum

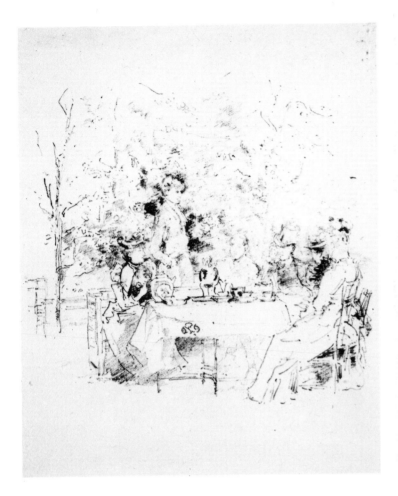

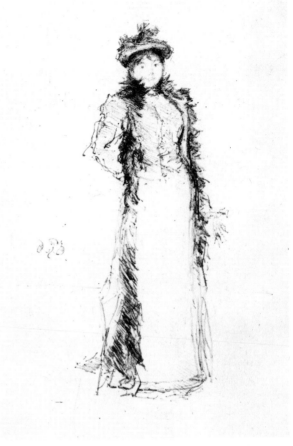

63 THE GARDEN
Lithograph. 1891.
Signed with the Butterfly. 17 × 18.7cm. (6¾ × 7⅜in.)
The subject portrays a tea-party in the garden of Whistler's house in Cheyne Walk, Chelsea. Mr Walter Sickert stands between Mrs Brandon Thomas, and to the right, Mr Starr, Mr Brandon Thomas, Mrs Whistler and Miss Philip. The artist's wife and Miss Philip are seen on the extreme right.
Way: 38. W: 6.

British Museum

64 TRIXIE
Lithograph. 1892–94.
Signed with the Butterfly. 18.5 × 9.8cm. (7¼ × 3⅞in.)
Unrecorded by Way.
This is a portrait of the artist's wife. Probably a study made in Paris where the artist and his wife lived for a while.

University of Glasgow, Birnie Philip Bequest

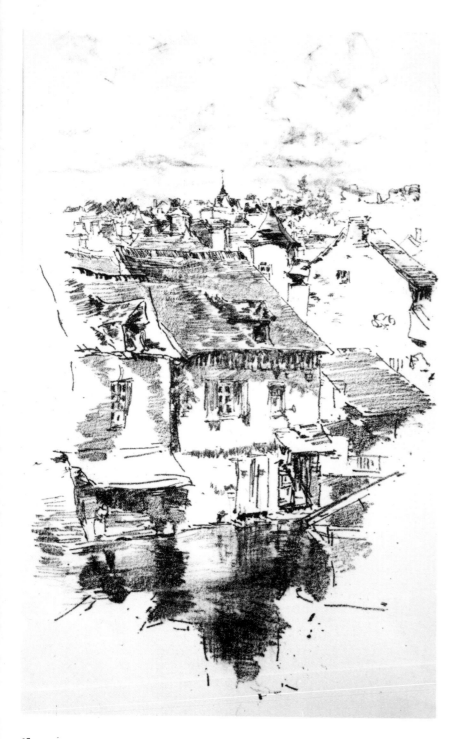

65 VITRÉ: THE CANAL, BRITTANY
Lithograph. 1893.
Signed with the Butterfly. 24 × 14.8cm. ($9\frac{1}{4}$ × $5\frac{7}{8}$in.)
Way: 39. W: 32. Reprinted by Goulding.
First use of the stump by Whistler.

British Museum

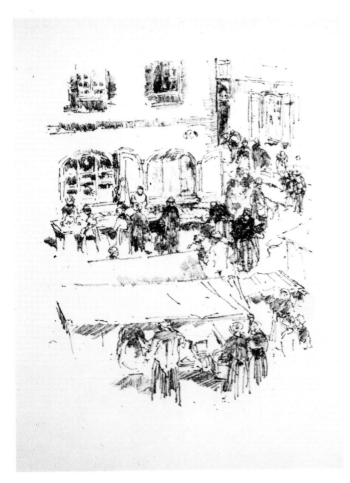

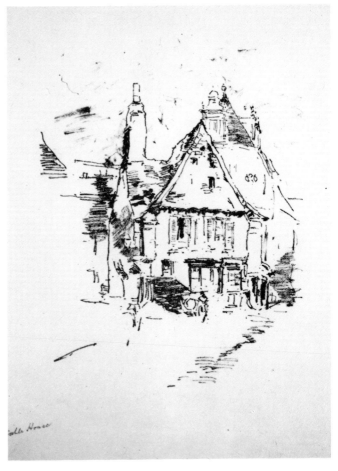

66 THE MARKET-PLACE, VITRÉ
Lithograph. 1893.
Signed with the Butterfly. 19.8 × 16cm. (7$\frac{7}{8}$ × 6$\frac{1}{2}$in.)
Way: 40. W: 12.

British Museum

67 GABLED ROOFS
Lithograph. 1893.
Signed with the Butterfly. 20 × 15.8cm. (7$\frac{3}{4}$ × 6$\frac{1}{4}$in.)
Way: 41. W: 12.

British Museum

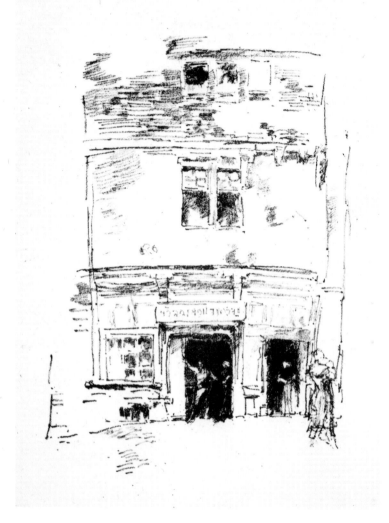

68 THE CLOCKMAKER'S HOUSE, PAIMPOL
Lithograph. 1893.
Signed with the Butterfly. 20.2 × 14.5cm. (8 × 5¾in.)
Way: 42. W: 12. Reprinted by Goulding.

British Museum

69 THE FIREPLACE
Lithograph. 1893.
No Signature. 17.7 × 15.8cm. (7 × 6¼in.)
Way: 133. W: 12.

British Museum

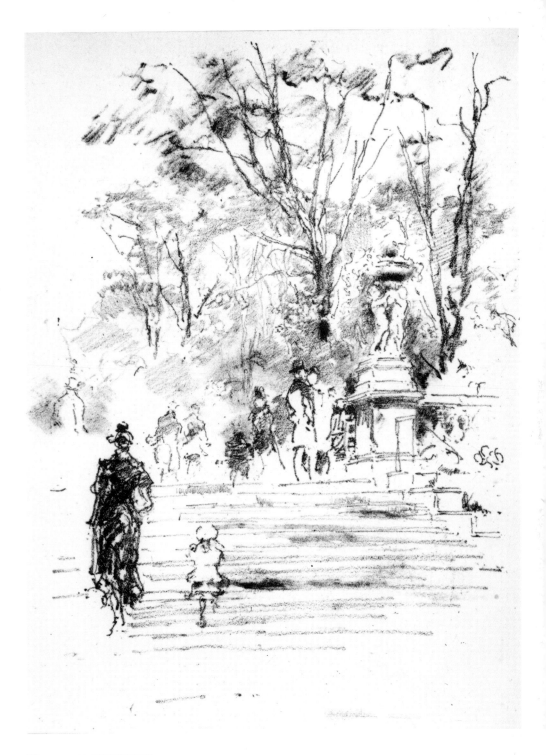

70 THE STEPS, LUXEMBOURG
Lithograph. 1893.
Signed with the Butterfly. 21 × 15.8cm. (8¼ × 6¼in.)
Way: 43. W: 15. Reprinted by Goulding.

British Museum

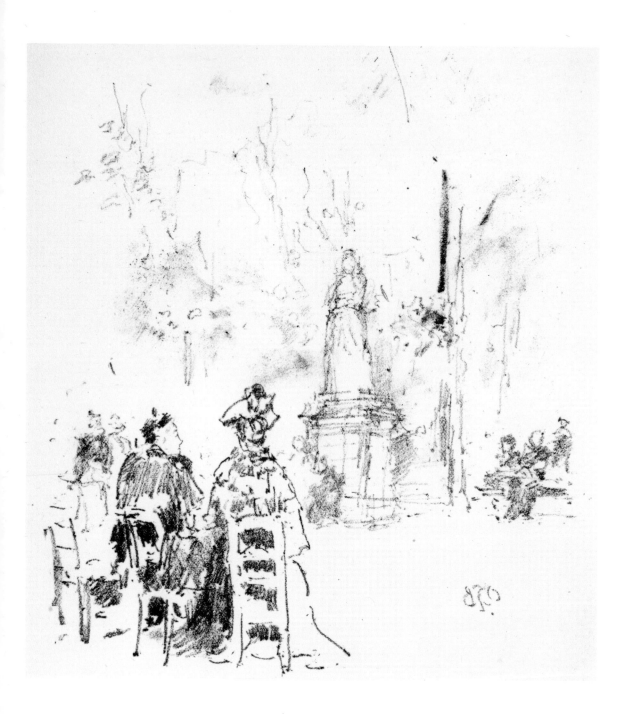

71 CONVERSATION UNDER THE STATUE, LUXEMBOURG GARDENS
Lithograph. 1893.
Signed with the Butterfly. 17 × 15cm. (6¾ × 6in.)
Way: 44. W: 15. Reprinted by Goulding.

British Museum

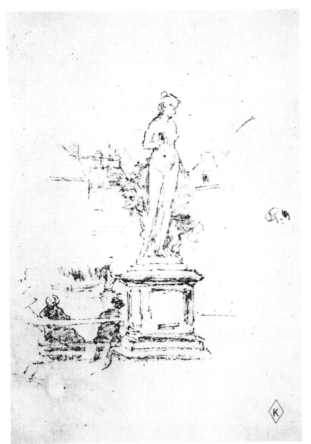

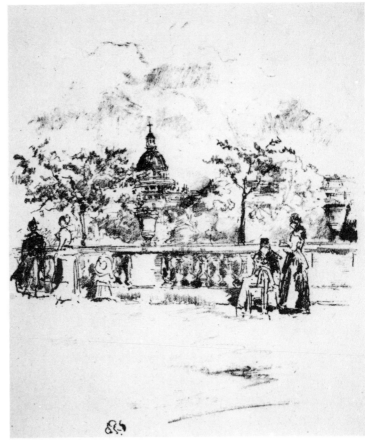

72 THE STATUE, LUXEMBOURG GARDENS
Lithograph. 1893.
Signed with the Butterfly. 12.6 × 10cm. (5 × 4in.)
Unrecorded in Way.

British Museum

73 THE PANTHEON, FROM THE TERRACE OF THE LUXEMBOURG
GARDENS
Lithograph. 1893.
Signed with the Butterfly. 18 × 16cm. (7⅛ × 6⅜in.)
Way: 45. W: 15. Reprinted by Goulding.

British Museum

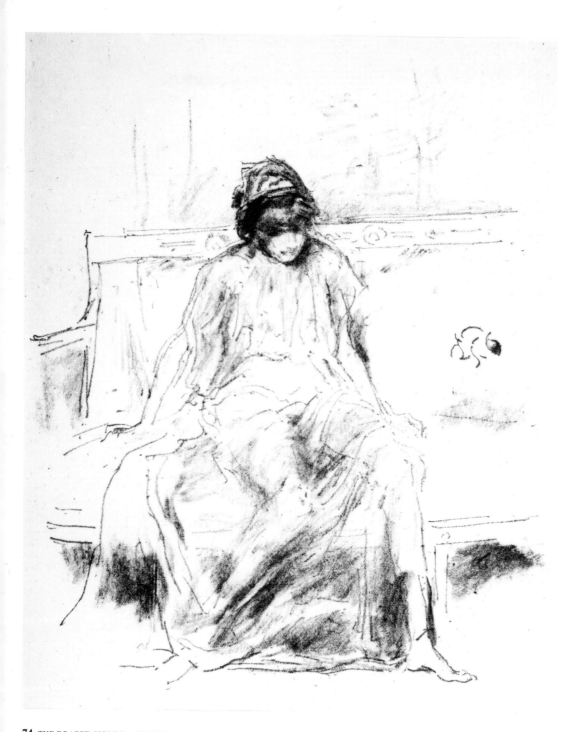

74 THE DRAPED FIGURE – SEATED
Lithograph. 1893.
Signed with the Butterfly. 18 × 16cm. (7⅛ × 6⅜ in.)
Way: 46. W: 15. Reprinted by Goulding.
An edition of 100 was printed by Way for *L'Estampe Originale*.
Goulding's printing was additional.

British Museum

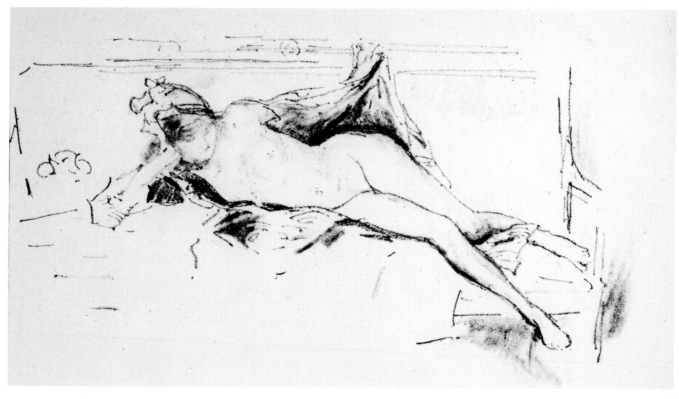

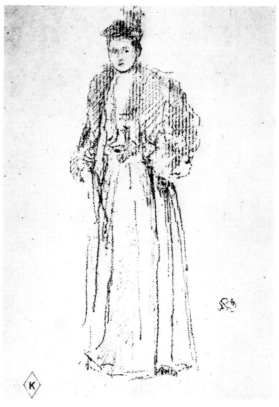

75 NUDE MODEL RECLINING
Lithograph. 1893.
Signed with the Butterfly. 11.4 × 22cm. (4½ × 8¾in.)
Way: 47. W: 25. Reprinted by Goulding.

British Museum

76 PORTRAIT STUDY: MISS CHARLOTTE R. WILLIAMS OF
BALTIMORE
Lithograph. *c.* 1893–94.
Signed with the Butterfly. 15.7 × 7cm. (6¼ x 2¾in.)
Way: 149. Printed in Paris.

British Museum

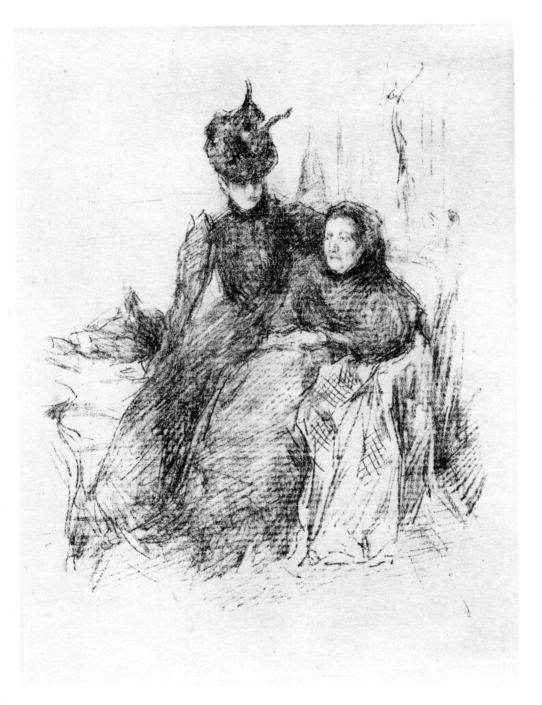

77 LA MÈRE MALADE

Lithograph. *c.* 1893–94.

Signed with the Butterfly. 19 × 15.6cm. (7$\frac{1}{2}$ × 6$\frac{3}{16}$ in.)

Unrecorded by Way.

This is a portrait of Mrs Birnie Philip and her daughter, probably printed by Clot, in Paris. Professor Young feels that the title of this lithograph should be 'Mother and Daughter,' there being no authority for the title 'La Mère Malade' which it is currently given in the Glasgow University records. In fact the print is illustrated as 'Mother and Daughter' in the Pennell's *Whistler Journal* (Philadelphia: 1921), facing page 13.

Professor Young also notes that the mark put centrally at the bottom of this print may be a collector's mark, or a somewhat feeble attempt at a butterfly. He also takes the view that the daughter is probably Whistler's sister-in-law, Ethel Birnie Philip, later Mrs Charles Whibley.

University of Glasgow Birnie Philip Bequest.

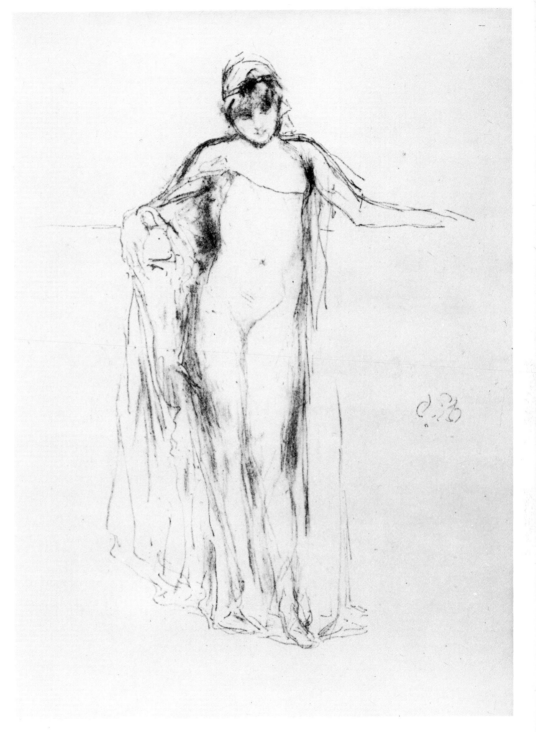

78 DRAPED MODEL STANDING
Lithograph. *c.* 1894.
Signed with the Butterfly. 20.5 × 16.1cm. (8⅛ × 6 1/16 in.)
Unrecorded by Way.

University of Glasgow. Birnie Philip Bequest

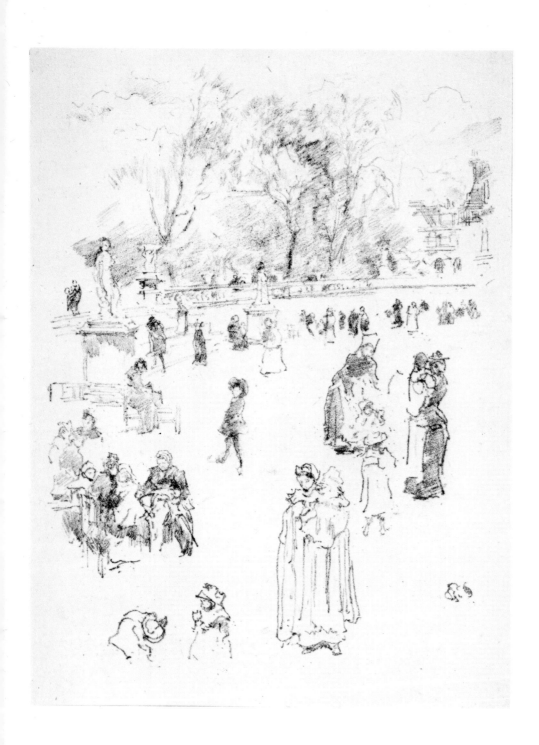

79 NURSEMAIDS: LES BONNES DU LUXEMBOURG
Lithograph. 1894.
Signed with the Butterfly. 19.8 × 15.5cm. (7⅞ × 6⅛in.)
Way: 48. W: 26. Reprinted by Goulding.
Published in the *Art Journal*.

British Museum

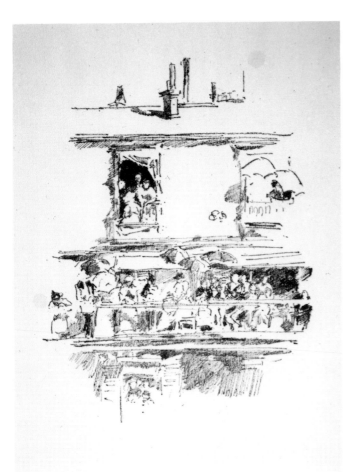

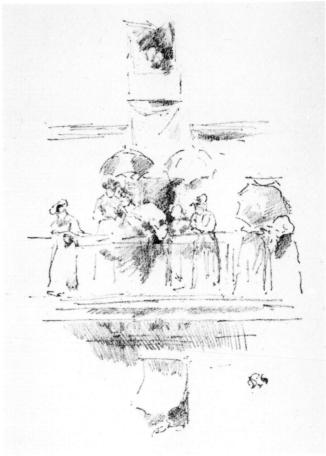

80 THE LONG BALCONY
Lithograph. 1894.
Signed with the Butterfly. 20.2 × 15.8cm. (8 × 6¼in.)
Way: 49. W: 28. Reprinted by Goulding.

British Museum

81 THE LITTLE BALCONY
Lithograph. 1894.
Signed with the Butterfly. 19.8 × 13.5cm. (7⅞ × 5⅜in.)
Way: 50. W: 28. Reprinted by Goulding.

British Museum

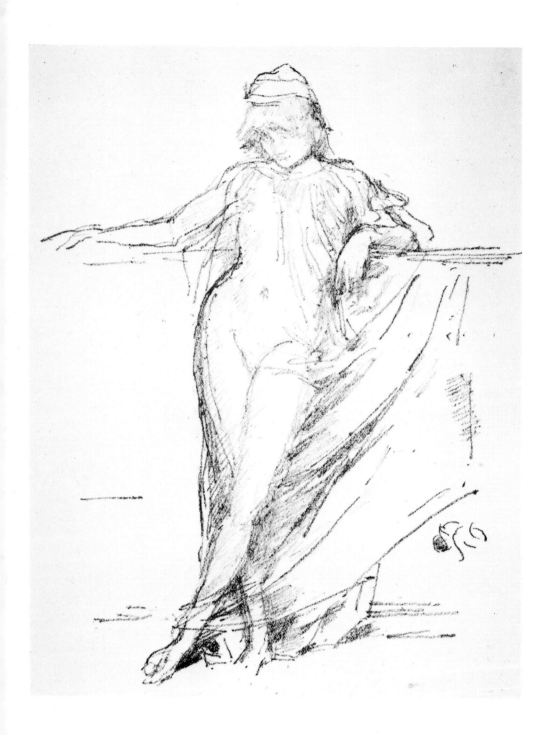

82 THE LITTLE DRAPED FIGURE – LEANING
Lithograph. 1894.
Signed with the Butterfly. 17.5 × 14.5cm. (7 × 5¾in.)
Way: 51. W: 48. Reprinted by Goulding.

British Museum

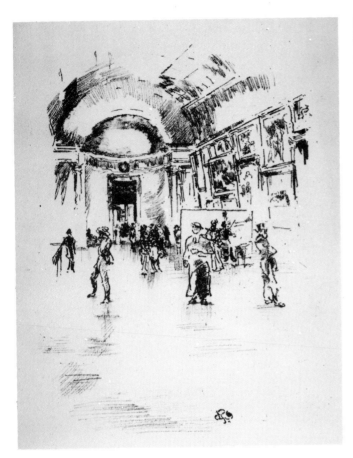

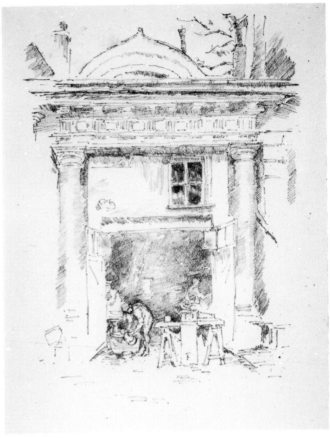

83 THE LONG GALLERY, LOUVRE
Lithograph. 1894.
Signed with the Butterfly. 21.5 × 15cm. (8½ × 6in.)
Way: 52. W: 28. Reprinted by Goulding.
Published in *The Studio*. Studio Stamp.

British Museum

84 THE WHITESMITHS, IMPASSE DES CARMÉLITES
Lithograph. 1894.
Signed with the Butterfly. 18.6 × 16.1cm: (8⅛ × 6⅜in.)
Way: 53. W: 28. Reprinted by Goulding.

British Museum

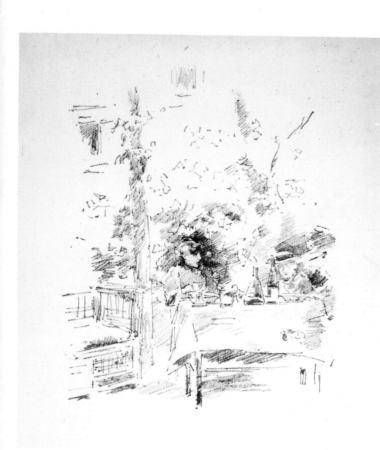

85 TÊTE-A-TÊTE IN THE GARDEN
Lithograph. 1894.
Signed with the Butterfly. 19.3 × 16.5cm. (7⅝ × 6½in.)
Way: 54. W: 25. Reprinted by Goulding.

British Museum

86 THE TERRACE, LUXEMBOURG
Lithograph. 1894.
Signed with the Butterfly. 8.5 × 20.8cm. (3⅜ × 8¼in.)
Way: 55. W: 25. Reprinted by Goulding.

British Museum

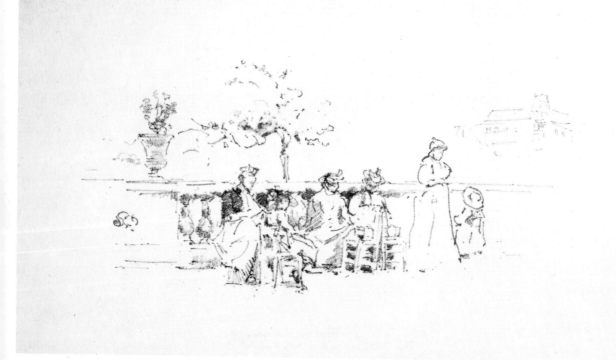

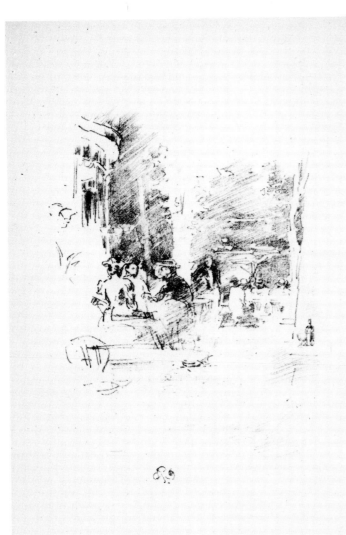

87 THE LITTLE CAFÉ AU BOIS
Lithograph. 1894.
Signed with the Butterfly. 21 × 15.5cm. (8¼ × 6⅛in.)
Way: 56. W: 28. Reprinted by Goulding.

British Museum

88 LATE PICQUET
Lithograph. 1894.
Signed with the Butterfly. 18 × 15cm. (7⅛ × 6in.)
Way: 57. W: 25. Reprinted by Goulding.

British Museum

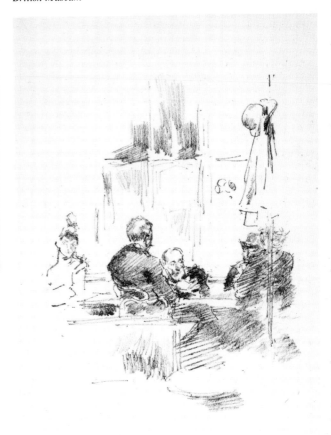

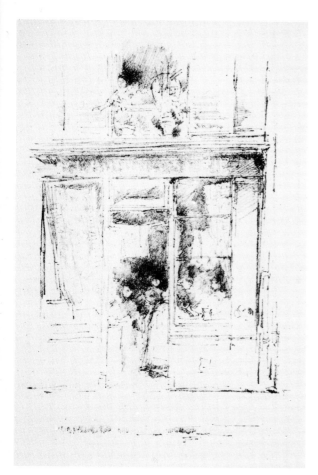

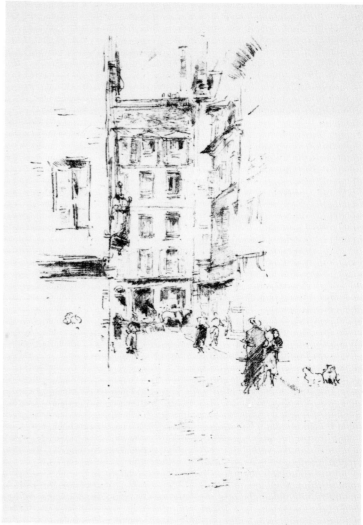

89 THE LAUNDRESS – LA BLANCHISSEUSE DE LA PLACE DAUPHINE
Lithograph. 1894.
Signed with the Butterfly. 21.7 × 15.5cm. (9 × 6⅛in.)
Way: 58. W: 25. Reprinted by Goulding.

British Museum

90 RUE FURSTENBURG
Lithograph. 1894.
Signed with the Butterfly. 22 × 16cm. (8¾ × 6⅜in.)
Way: 59. W: 26. Reprinted by Goulding.

British Museum

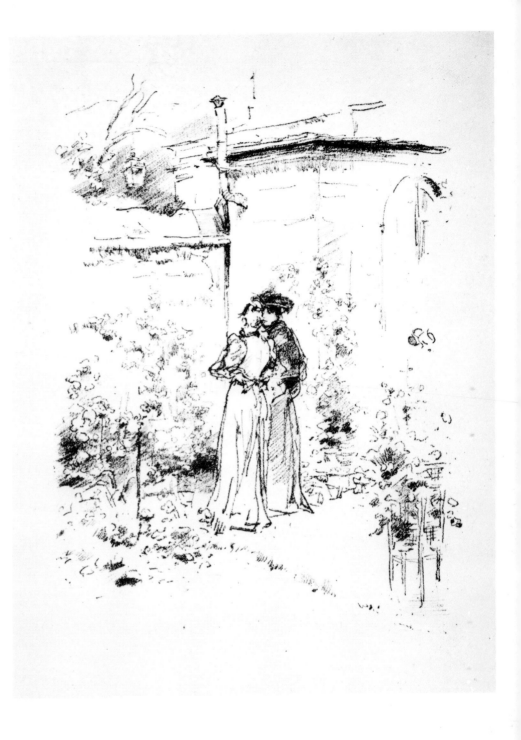

91 CONFIDENCES IN THE GARDEN
Lithograph. 1894.
Signed with the Butterfly. 14.5 × 16cm. (5⅜ × 6⅜in.)
Way: 60. W: 28.

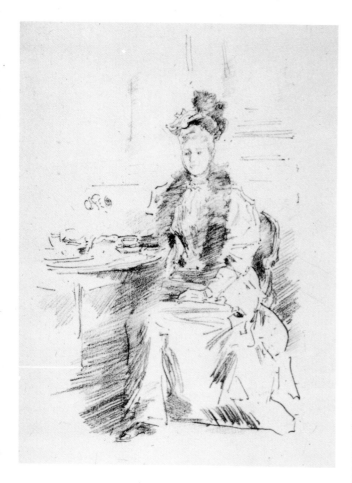

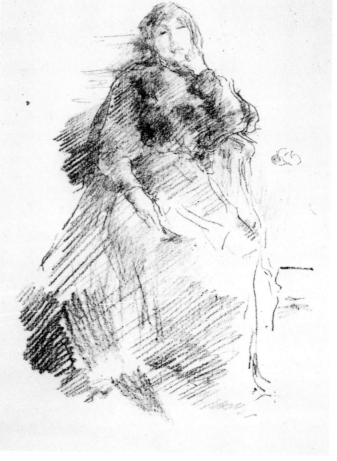

92 LA JOLIE NEW YORKAISE
Lithograph. 1894.
Signed with the Butterfly. 21.7 × 15cm. (9 × 6in.)
Way: 61. W: 25. Reprinted by Goulding.

British Museum

93 LA BELLE DAME, PARESSEUSE
Lithograph. 1894.
Signed with the Butterfly. 24 × 17cm. (9¼ × 6¼in.)
Way: 62. W: 28.

British Museum

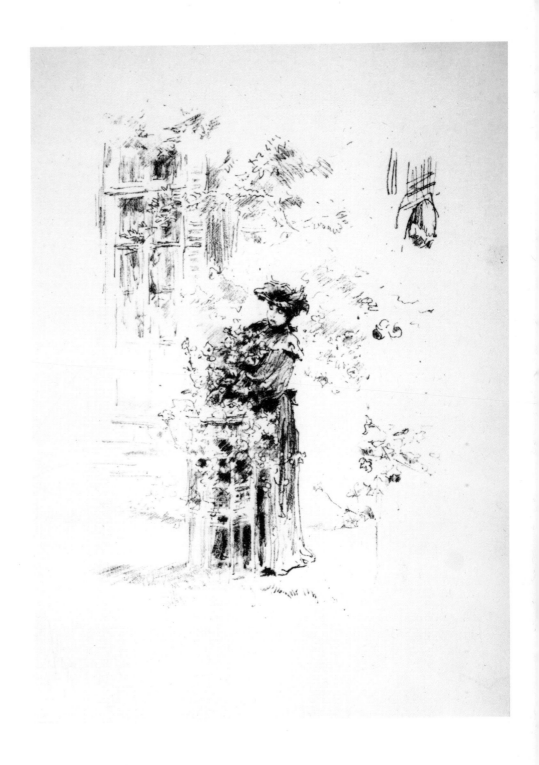

94 LA BELLE JARDINIÈRE
Lithograph. 1894.
Signed with the Butterfly. 22.2 × 15.8cm. ($8\frac{7}{8}$ × $6\frac{1}{4}$in.)
Way: 63. W: 25.

British Museum

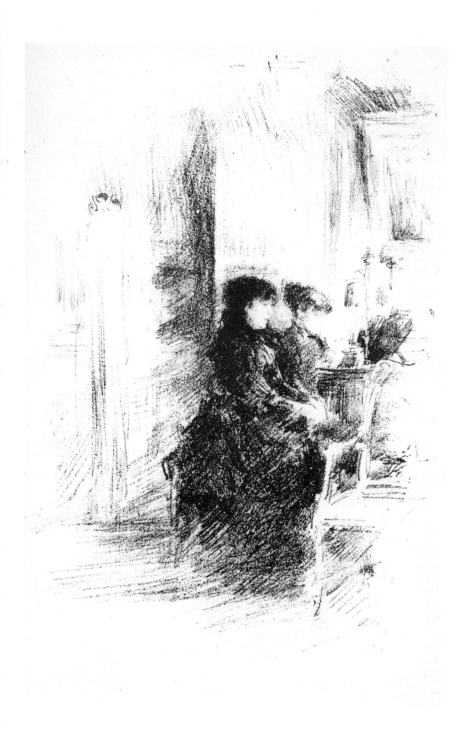

95 THE DUET
Lithograph. 1894.
Signed twice with the Butterfly. 24.3 × 16cm. (9⅝ × 6⅜in.)
Way: 64. W: 39.
Another version (Way: 65) is much paler (97) and carries the
Butterfly signature on the right-hand side of the stone.

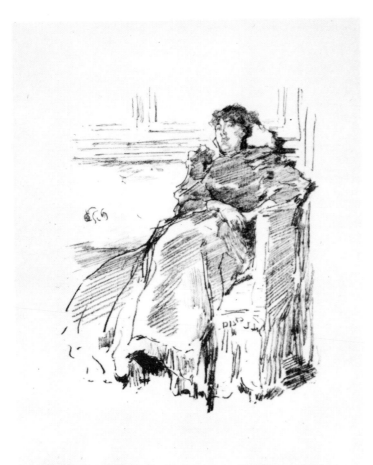

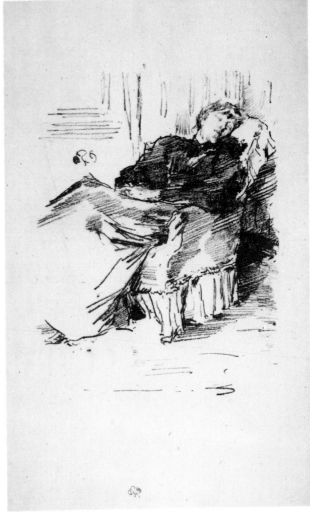

96 LA ROBE ROUGE
Lithograph. 1894.
Signed with the Butterfly. 18.6 × 15cm. (7⅛ × 6in.)
Way: 68. W: 23. Reprinted by Goulding.
Published in *The Studio*. Studio Stamp.

British Museum

97 LA BELLE DAME ENDORMIE
Lithograph. 1894.
Signed with the Butterfly. 20 × 15.5cm. (7¾ × 6⅛in.)
Way: 69. W: 42.

British Museum

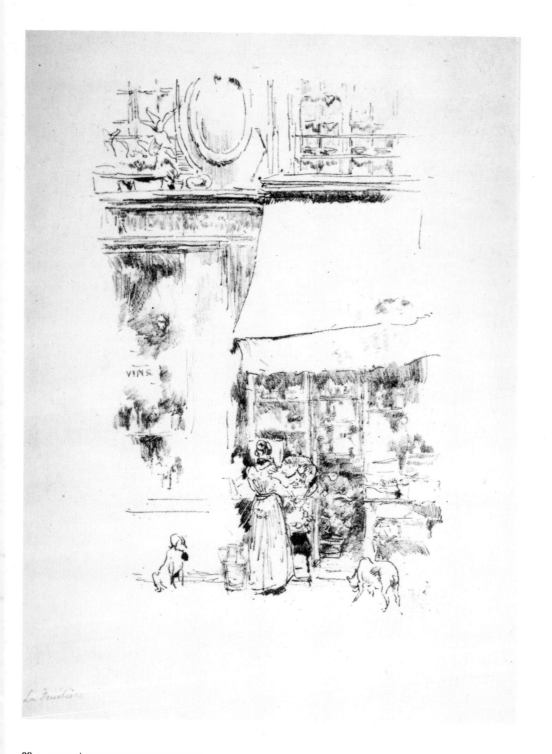

98 LA FRUITIÈRE DE LA RUE DE GRENELLE
Lithograph. 1894.
Signed with the Butterfly. 21.7 × 15.5cm. (9 × 6⅛in.)
Way: 70. W: 33. Reprinted by Goulding.

British Museum

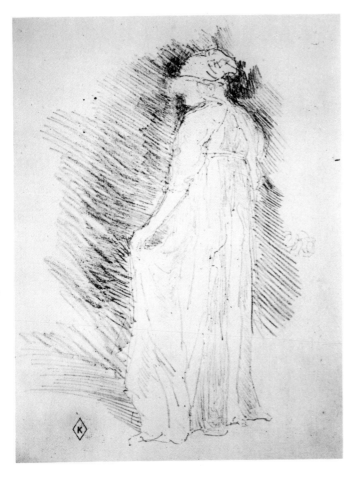

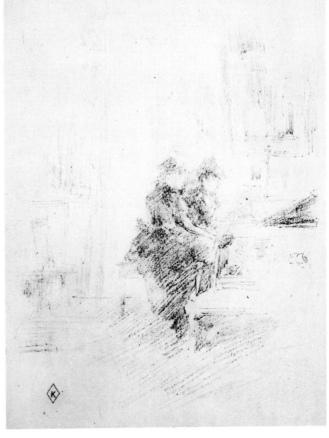

99 THE DRAPED FIGURE, BACK VIEW
Lithograph. 1894.
Signed with the Butterfly. 10.5 × 15.5cm. (8⅛ × 6⅛in.)
Way: 67. Printed in Paris.

British Museum

100 THE DUET: NO.2
Lithograph. 1894.
Signed with the Butterfly. 21.5 × 18cm. (8½ × 7⅛in.)
Way: 65. Printed in Paris.
This is the paler version of Way: 64, referred to in the caption
to Plate 95.

British Museum

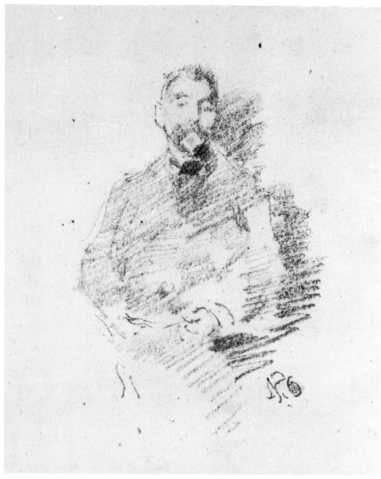

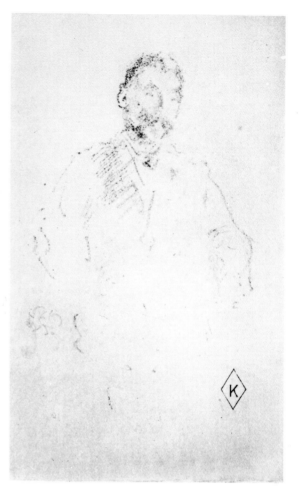

101 STÉPHANE MELLARMÉ No. 1
Lithograph. 1894.
Signed with the Butterfly. 9.5 × 7cm. (3¾ × 2¾in.)
Used as a frontispiece for the first edition of Mallarmé 'Vers et Prose,' 1893, and printed in Paris as a lithograph in 1894.
Way: 66. Printed in Paris.
Whistler's flair for experiment is revealed in an account of his work on the Mallarmé lithographs given in Pennell's life (Vol. II, pages 134–135). 'J' is quoted as writing from Paris in 1893: 'It was the first time I had ever seen Whistler working on a lithograph . . . He had found at Belfont's or Lemercier's some thin textureless transfer paper, thin as tissue paper which delighted him . . . When he was doing the Mallarmé, I remember he put the paper down on a roughish book cover. He liked the grain the cover gave him, for it was not mechanical, and, when the grain seemed to repeat itself, he would shift the drawing, and thus get a new surface . . . The Mallarmé was not sent to Way but printed by Belfont in Paris.'
Belfont printed a number of Whistler's Paris lithographs, but there is no traceable indication of how many proofs were taken of each. It is most likely however, that the printings were always few, and that consequently the Paris lithographs are especially rare. Paris printings succeed Whistler's quarrel with Way in 1896.

British Museum

102 STÉPHANE MALLAMÉ No. 2
Lithograph. 1894.
Signed with the Butterfly. 9.5 × 6.3cm. (3¾ × 2½in.)
Way: 150. Printed in Paris.

British Museum

103 THE MAN WITH A SICKLE
Lithograph. 1894.
Signed with the Butterfly. 22 × 15.8cm. (9½ × 6¼in.)
Way: 141. W: 8.

British Museum

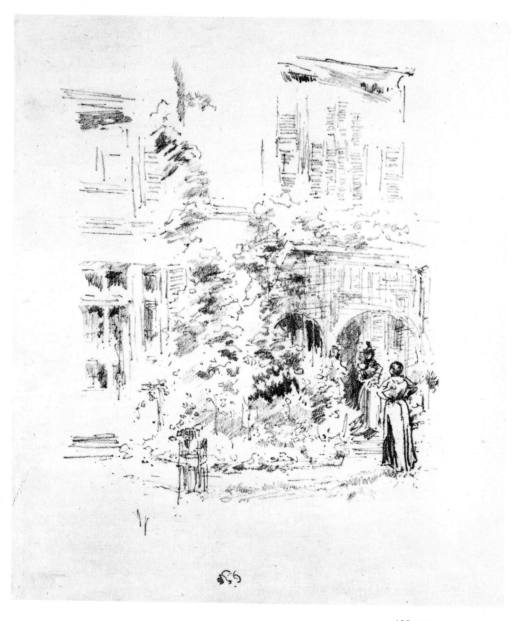

104 THE GARDEN PORCH
Lithograph. 1894.
Signed with the Butterfly. 22.2 × 15.8cm. (8¾ × 6¼in.)
Way: 140. W: 8.

British Museum

105 THE SISTERS
Lithograph. 1894.
Signed with the Butterfly. 14.8 × 21.7cm. (5⅞ × 9in.)
Way: 71. W: 50.

British Museum

106 THE SISTERS
Lithograph. 1894.
A first state of 105 in which the outlines of the faces are particularly heavy. These were modified and reduced in tone by the artist, as were other passages of the drawing to produce a much more delicate, final effect.
Way: 71A.

British Museum

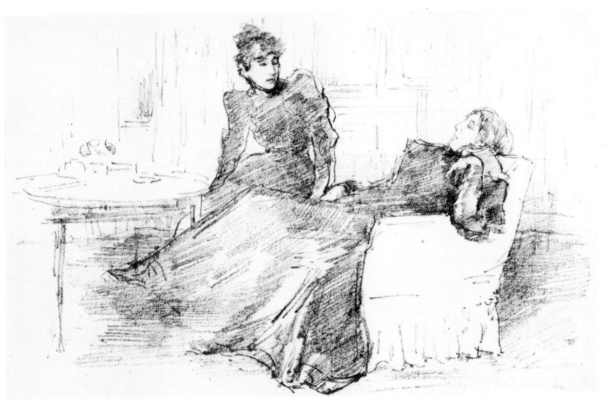

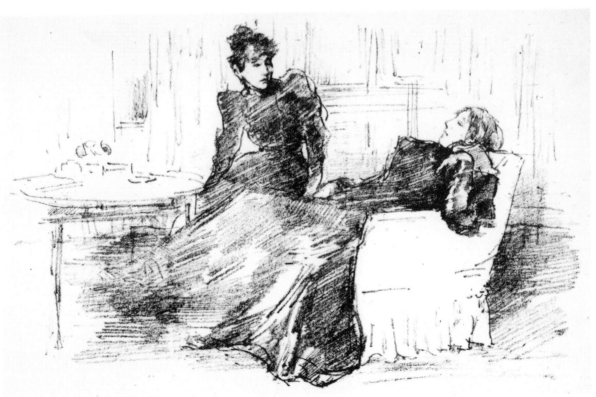

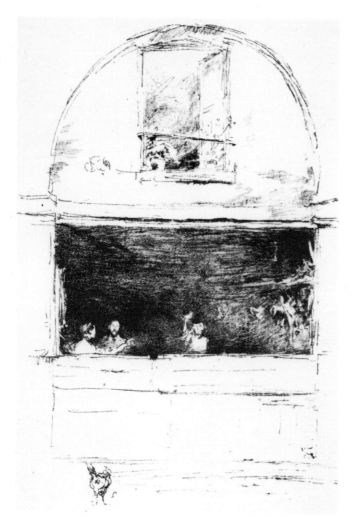 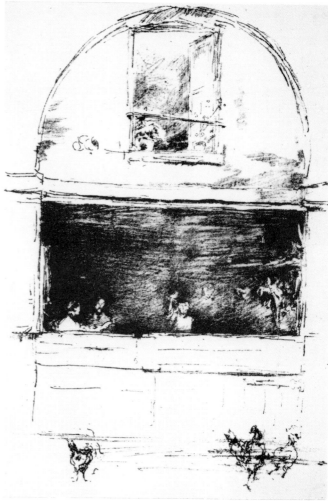

107 THE FORGE: PASSAGE DU DRAGON
Lithograph. 1894.
Signed with the Butterfly. 21.3 × 15.5cm. (8⅝ × 6⅛in.)
Way: 72. W: 35. Reprinted by Goulding.

British Museum

108 THE FORGE: PASSAGE DU DRAGON
Lithograph. 1894.
The first state of 107, before the background was darkened and
the two hens on the right of the composition removed.
Way: 72A.

British Museum

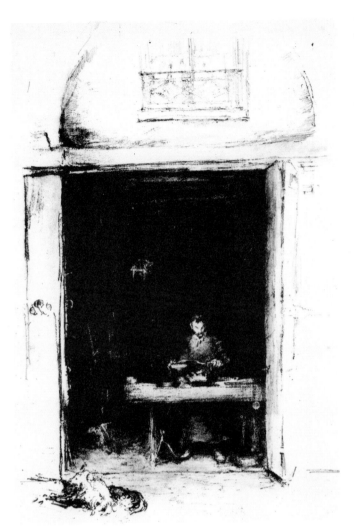

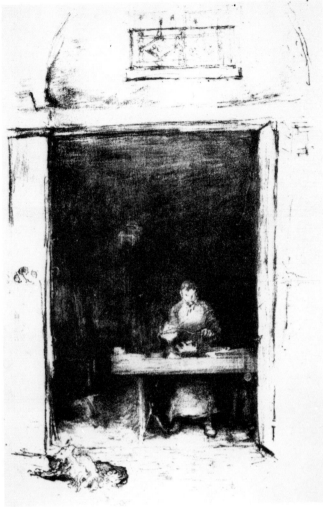

109 THE SMITH: PASSAGE DU DRAGON
Lithograph. 1894.
Signed with the Butterfly. 26.8 × 17.4cm. (10⅝ × 6⅞in.)
Way: 73. W: 34. Reprinted by Goulding.

British Museum

110 THE SMITH: PASSAGE DU DRAGON
Lithograph. 1894.
The first state of 109 before the artist modified the white areas
in the chest and apron of the Smith, and intensified the black-
ness of the background.
Way: 73A.

British Museum

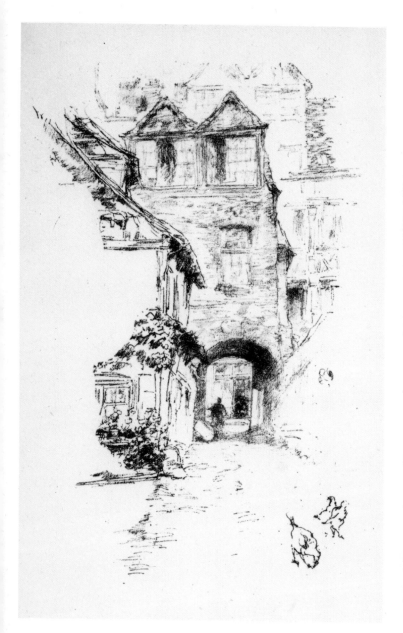

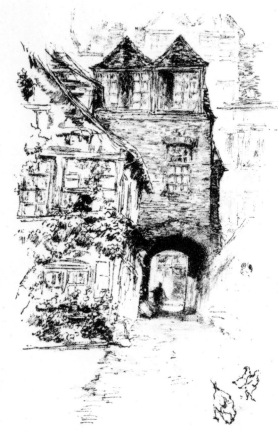

111 THE PRIEST'S HOUSE – ROUEN
Lithograph. 1894.
Signed with the Butterfly. 24 × 15.8cm. (9¼ × 6¼in.)
Way: 74. W: 15. Reprinted by Goulding.

British Museum

112 THE PRIEST'S HOUSE – ROUEN
Lithograph. 1894.
First state of 111 of which about 12 proofs were taken. Tone values generally dark, the whole conception was lightened to produce the final, more subtle state.
Way: 74A.

British Museum

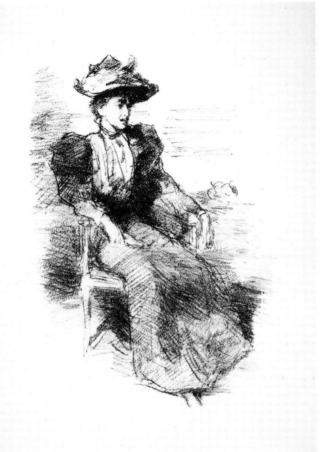

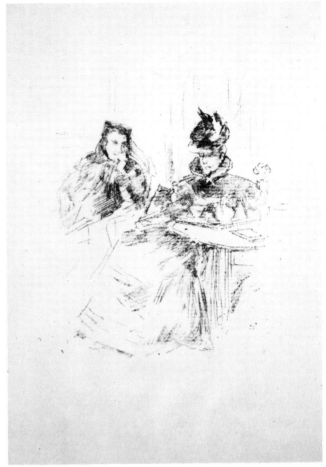

113 PORTRAIT OF MISS HOWELLS
Lithograph. 1895.
Signed with the Butterfly. 22.3 × 17cm. (8⅞ × 6¾in.)
Way: 75. W: 6.
Probably the second state. There are two other states of this
lithograph listed as Way: 75a and 75b. The only print I have been
able to examine is the one reproduced here from the Department
of Prints and Drawings in the British Museum. Way notes that
the first state shows the drawing as transferred to the stone, and
without any retouching. In the second state much delicate
modelling has been added to the features, and much soft shading
applied all over the subject, and especially to the background,
behind the sitter's head, and to the right of the figure which in the
first state was white. In the final state much of the work on the
background to the right has been scraped away again.

British Museum

114 AFTERNOON TEA
Lithograph. *c.* 1895.
Signed with the Butterfly. 19 × 14cm. (7½ × 5½in.)
Way: 147. Printed in Paris.

British Museum

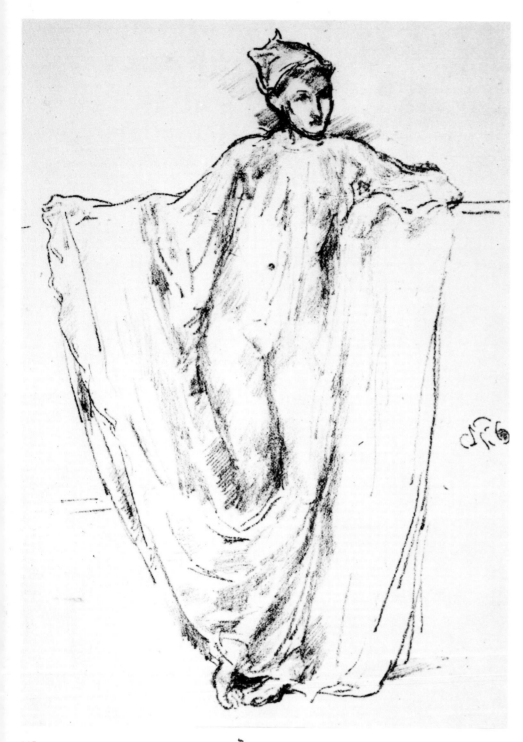

115 FIGURE STUDY
Lithograph. 1895.
Signed with the Butterfly. 19 × 14cm. (7¼ × 5½ in.)
Way: 76. W: 6.

British Museum

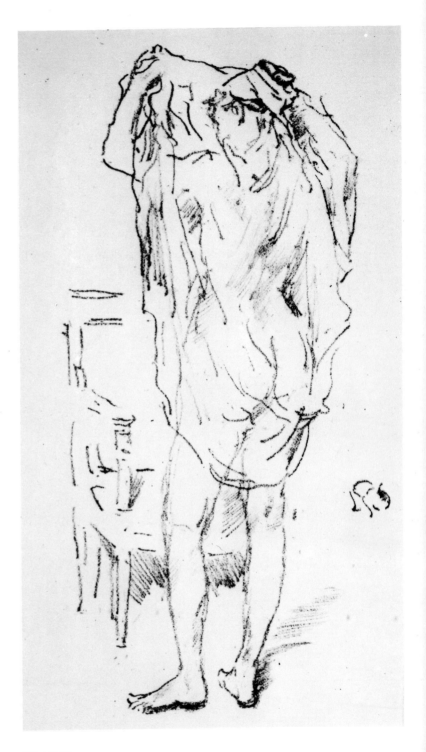

116 STUDY
Lithograph. 1895.
Signed with the Butterfly. 18 × 9.2cm. (7$\frac{1}{8}$ × 3$\frac{5}{8}$in.)
Way: 77. W: 6.

British Museum

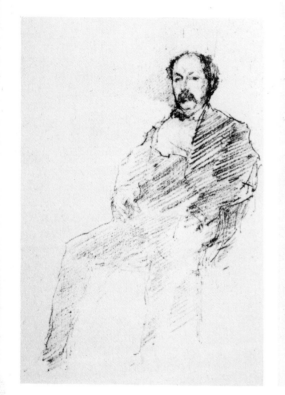

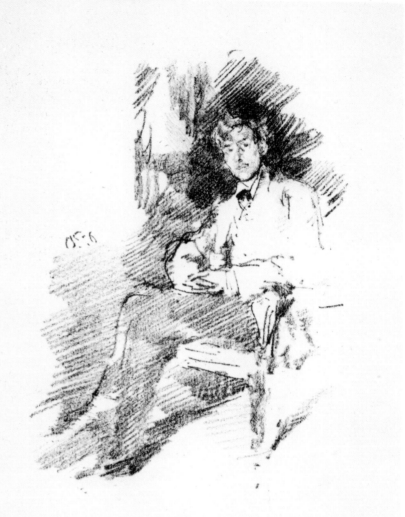

117 THE DOCTOR
Lithograph. 1895.
Signed with the Butterfly. 18 × 9.2cm. (7⅛ × 3⅝in.)
This is a portrait of the artist's brother, Dr William Whistler.
Way: 78. W: 6.

British Museum

118 WALTER SICKERT
Lithograph. 1895.
Signed with the Butterfly. 19 × 14cm. (7½ × 5½in.)
Way: 79. W: 6.

British Museum

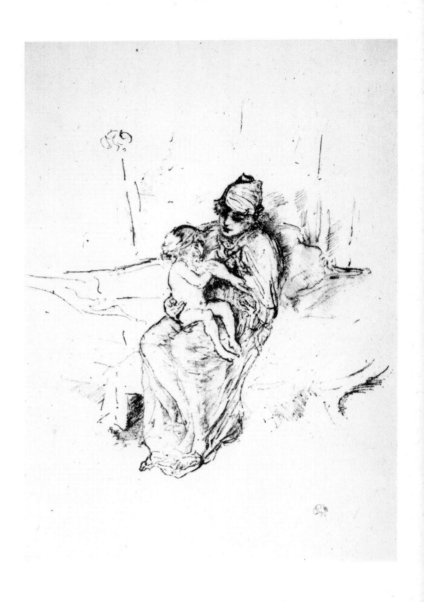

119 MOTHER AND CHILD No. 1.
Lithograph. 1895.
Signed with the Butterfly. 18 × 19cm. (7$\frac{1}{8}$ × 7$\frac{1}{2}$in.)
Way: 80. W: 33.
See note to plate 39.

British Museum

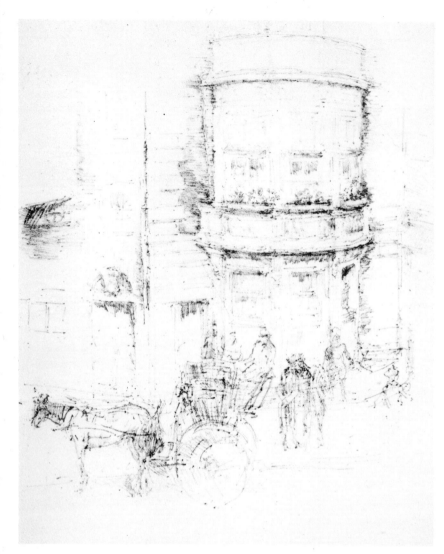

120 BACK OF THE GAIETY THEATRE
Lithograph. 1895.
Unsigned. 26 × 21.7cm. (10¼ × 9in.)
Way: 81. W: 6.

British Museum

121 GIRL WITH BOWL
Lithograph. 1895.
Signed with the Butterfly. 13.7 × 6.7cm. (5⅜ × 2⅝in.)
Way: 82. W: 12. Published in *L'Imagier*.

British Museum

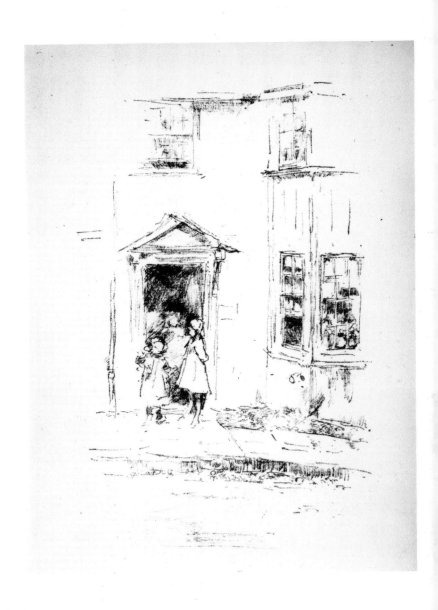

122 THE LITTLE DOORWAY, LYME REGIS
Lithograph. 1895.
Signed with the Butterfly. 23 × 15.5cm. (9⅛ × 6⅛in.)
Way: 83. W: 15. Reprinted by Goulding.
In the summer of 1895 the Whistlers moved to Lyme Regis for
Mrs Whistler's health. For a while Whistler worked here on his
paintings, etchings, and lithographs.

British Museum

123 THE MASTER SMITH
Lithograph. 1895.
Signed with the Butterfly. 10.5 × 7.3cm. (4$\frac{1}{8}$ × 2$\frac{7}{8}$in.)
Way: 84. W: 15. Reprinted by Goulding.

British Museum

124 THE GOOD SHOE
Lithograph. 1895.
Signed with the Butterfly. 16.8 × 12cm. (6$\frac{5}{8}$ × 4$\frac{3}{4}$in.)
Way: 86. W: 15.

British Museum

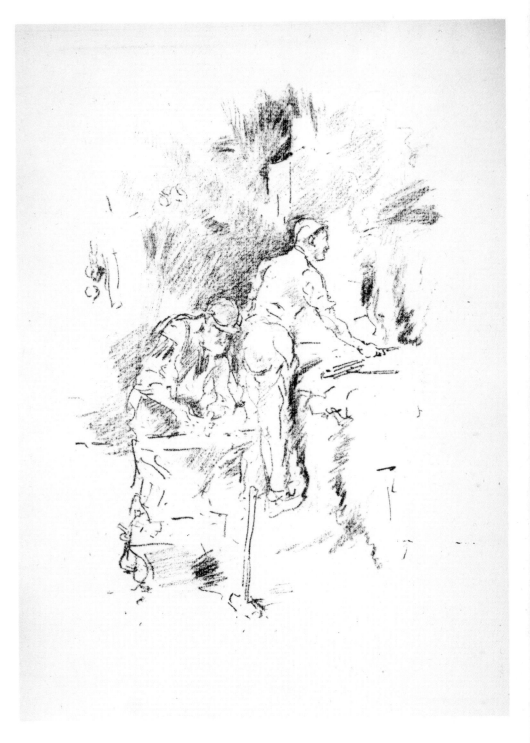

125 FATHER AND SON
Lithograph. 1895.
Signed with the Butterfly. 20.5 × 15cm. (8¼ × 6in.)
Way: 87. W: 15.

British Museum

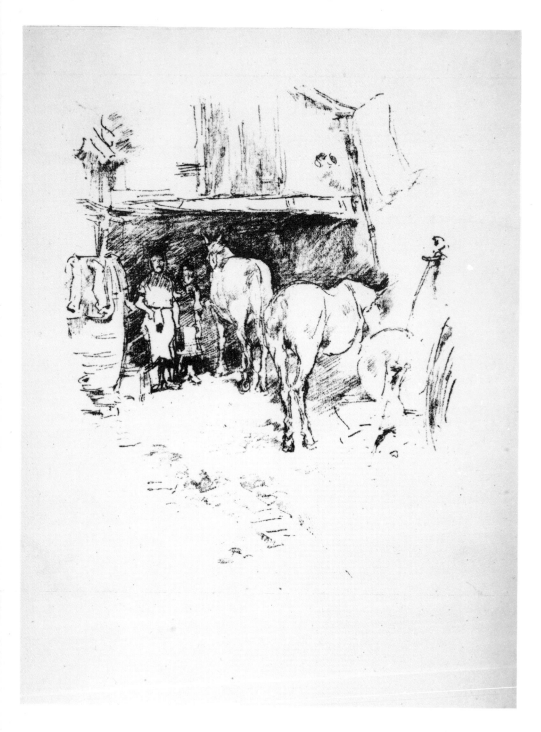

126 THE SMITH'S YARD
Lithograph. 1895.
Signed with the Butterfly. 18.5 × 15.8cm. (7¼ × 6¼in.)
Way: 88. W: 35. Reprinted by Goulding.
Published in *The Studio*. Studio Stamp.

British Museum

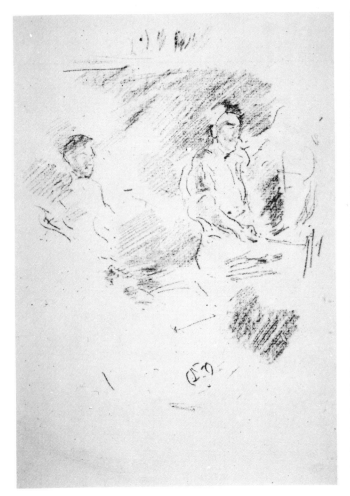

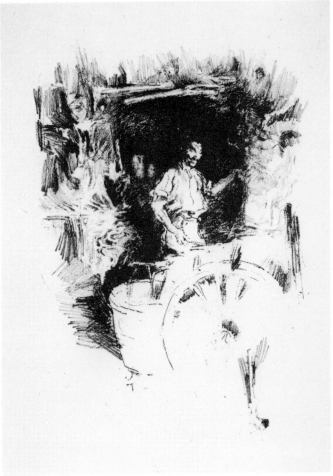

127 THE STRONG ARM
Lithograph. 1895.
Signed with the Butterfly. 20 × 15.8cm. (7¾ × 6¼in.)
Way: 89. W: 15. Reprinted by Goulding.

British Museum

128 THE BLACKSMITH
Lithograph. 1895.
Signed with the Butterfly. 21 × 15cm. (8¼ × 6in.)
Way: 90. W: 15. Reprinted by Goulding.
Final State.
Way lists two other states: 90a and 90b. Neither are reproduced
in the present volume since the differences are minimal. In 90a,
the first state, the overall effect is grey and soft. Shadows
almost confined to the square opening behind the figure and
principally obtained by the use of the stump. In 90b, the second
state, the general features are elaborated. Shadows in the recess
are strengthened. About ten proofs of the first state, and four of
the second state were taken.

British Museum

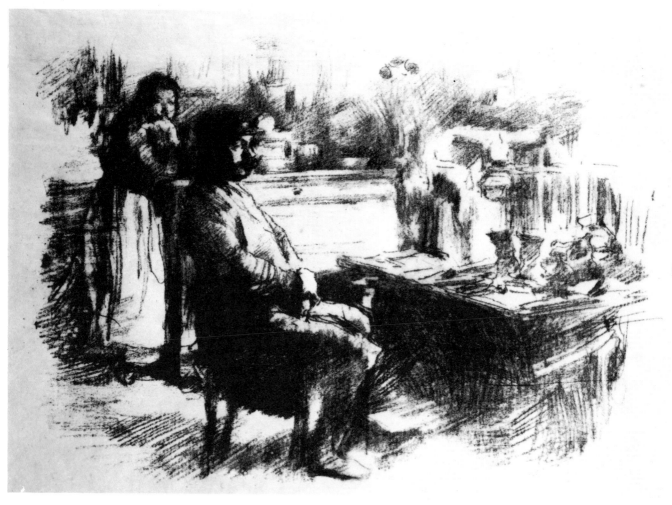

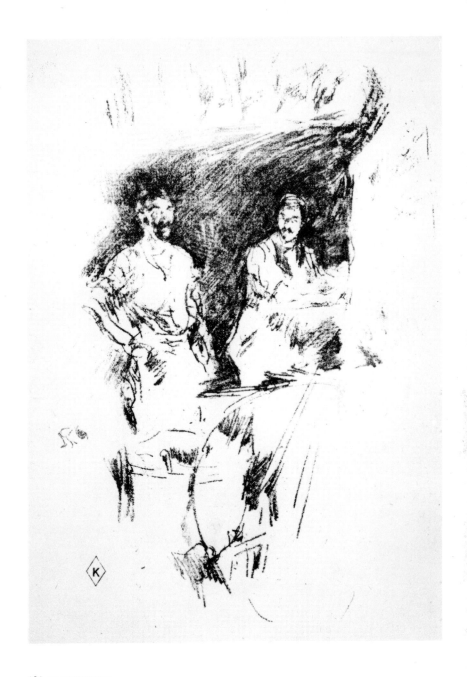

129 THE SHOEMAKER
Lithograph. *c.* 1895.
Signed with the Butterfly. 15.8 × 22cm. (6¼ × 8¾in.)
Way: 151. Printed in Paris.

British Museum

130 THE SUNNY SMITHY
Lithograph. 1895.
Signed with the Butterfly. 14 × 20.1cm. (5½ × 8in.)
Way: 85. W: 4.

British Museum

131 THE BROTHERS
Lithograph. 1895.
Signed with the Butterfly. 20.1 × 14cm. (8 × 5½in.)
Way: 91. W: 15.

British Museum

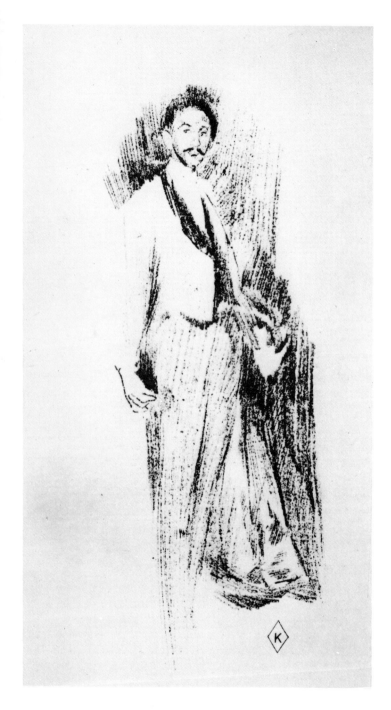

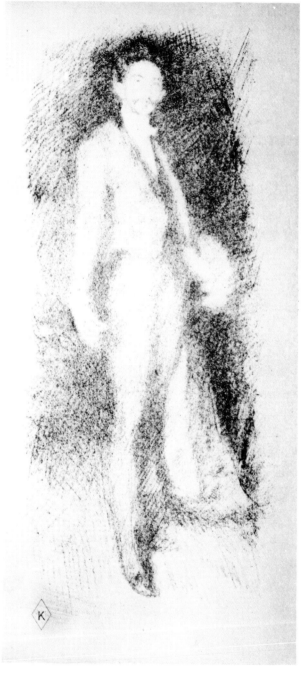

132 COUNT ROBERT DE MONTESQUION
Lithograph. 1895.
Unsigned. 20 × 7.3cm. ($7\frac{3}{4}$ × $2\frac{7}{8}$in.)
Printed in Paris.
Way: 139.

British Museum

133 COUNT ROBERT DE MONTESQUION
Lithograph. 1895.
Signed with the Butterfly. 20.1 × 9.5cm. (8 × $3\frac{3}{4}$in.)
Way: 138. Printed in Paris.

British Museum

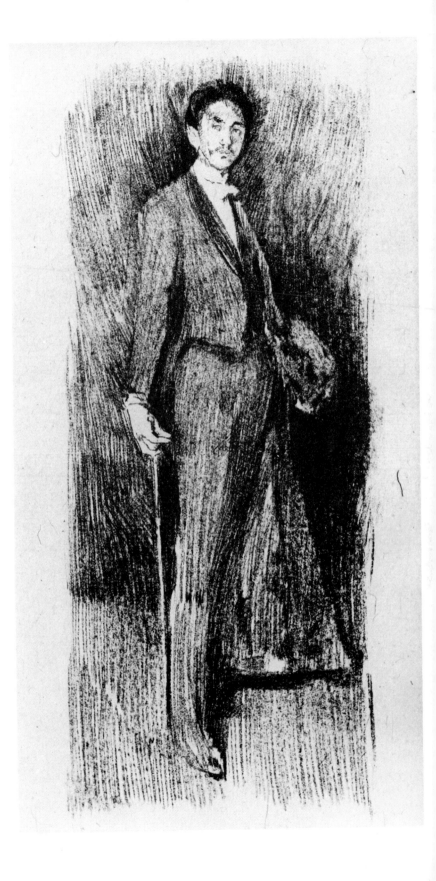

134 COMTE ROBERT DE MONTESQUION
Lithograph. 1895.
21 × 18.7cm. ($8\frac{5}{16}$ × $7\frac{3}{8}$in.)
Unrecorded by Way.
The fourth of Whistler's portraits of Montesquion.

University of Glasgow, Birnie Philip Bequest

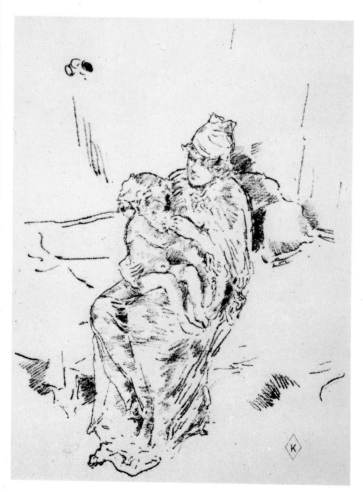

135 MOTHER AND CHILD: No 5
Lithograph. 1895.
Signed with the Butterfly. 19 × 14.8cm. ($7\frac{1}{2}$ × $5\frac{7}{8}$in.)
Way: 136. W: 4.
See note to plate 39.

British Museum

136 SKETCH OF A BLACKSMITH
Lithograph. 1895.
Unsigned. 10.7 × 9.5cm. ($4\frac{1}{4}$ × $3\frac{3}{4}$in.)
Way: 145. W: 3.

British Museum

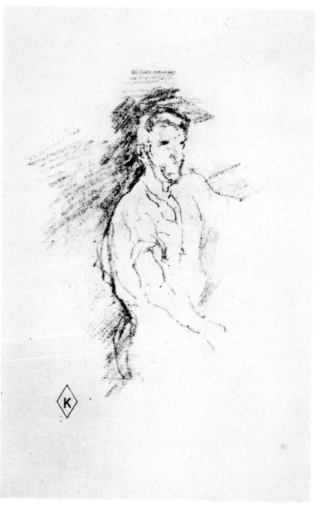

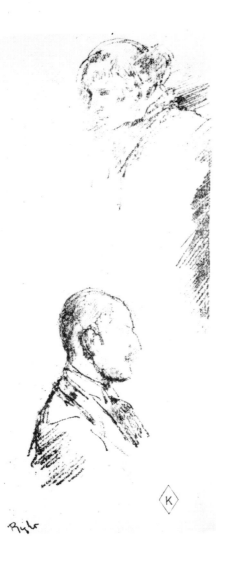

137 SKETCHES OF MISS PHILLIP AND MR A. STUDD
Lithograph. 1895.
Unsigned. 17.7 × 7.5cm. (7 × 3in.)
Way: 144. W: 3.

British Museum

138 COUNT ROBERT DE MONTESQUION
Lithograph. 1895.
Signed with the Butterfly. 20.1 × 9.5cm. (8 × 3¾in.)
Way: 137. W: 3. Printed in Paris.

British Museum

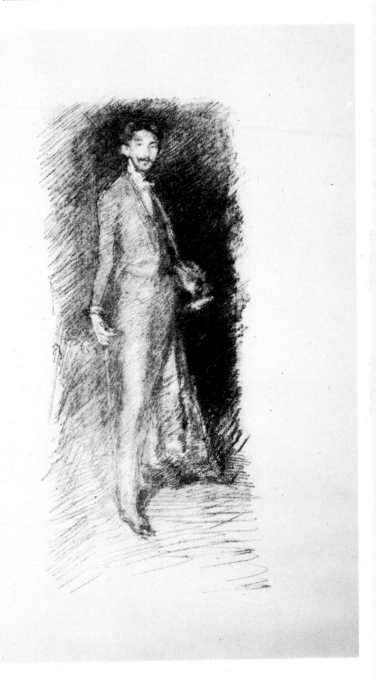

139 UNFINISHED SKETCH OF LADY HADEN
Lithograph. 1895.
Signed with the Butterfly. 30 × 19.6cm. ($11\frac{7}{8}$ × $7\frac{3}{4}$in.)
Way: 143. W: 6.
The sitter was Whistler's half-sister Deborah, wife of the surgeon
and etcher, Sir Seymour Haden.

British Museum

140 PORTRAIT OF DR WHISTLER
Lithograph. 1895.
Unsigned. 19 × 15cm. (7½ × 6in.)
Way: 142. W: 12.

British Museum

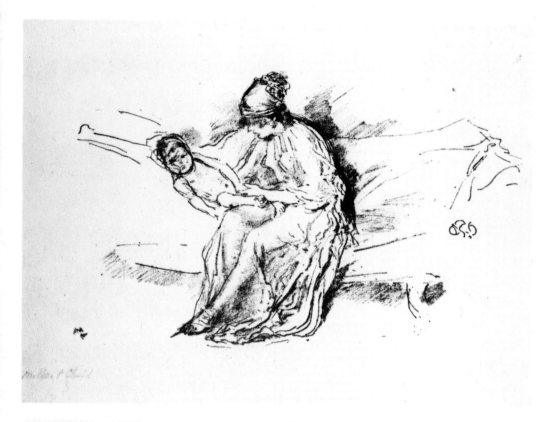

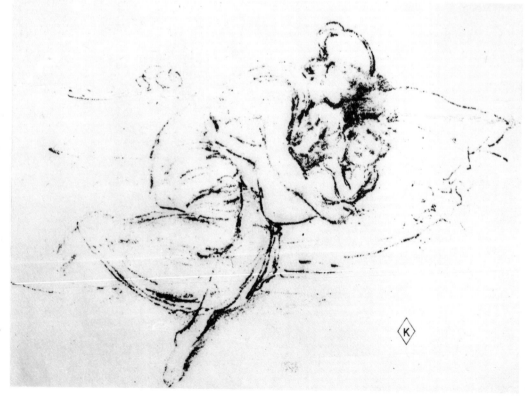

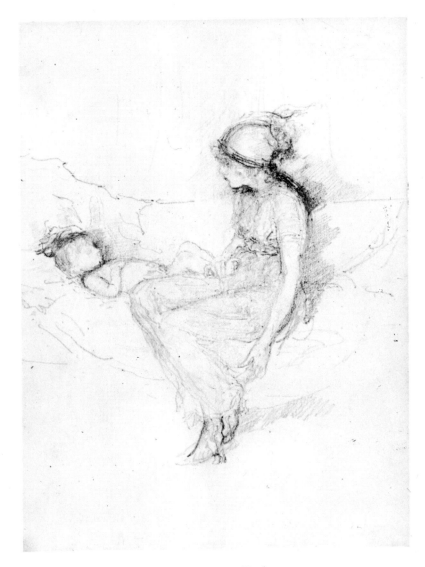

141 MOTHER AND CHILD: No. 4
Lithograph. 1895.
Signed with the Butterfly. 14.8 × 21cm. (5⅞ × 8¼in.)
Way: 135. Very few prints of this subject were taken, the stone having been considered a failure by the artist. The drawing was erased.
See note to Plate 39.

British Museum

142 MOTHER AND CHILD: No. 3
Lithograph. 1895.
Signed with the Butterfly. 14.8 × 21cm. (5⅞ × 8¼in.)
Way: 134.
Only a few proofs. This is the one of the series most noticeably spoiled in the process of transferring the drawing from a transfer paper onto the stone.
See note to Plate 39.

British Museum

143 MOTHER AND CHILD: No. 6
17.7 × 18.3cm. (7 × 7$\frac{5}{14}$ in.)
For details see note to Plate 39.

From a photograph in the Art Collections of the *University of Glasgow*

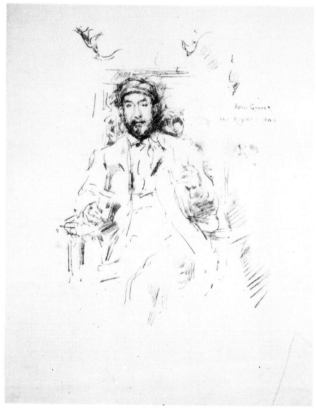

144 THE FAIR
Lithograph. 1895.
Signed with the Butterfly. 24 × 15.7cm. (9¼ × 6¼in.)
The subject portrays a night scene in Lyme Regis.
Way: 92. W: 15. Reprinted by Goulding.

British Museum

145 JOHN GROVE
Lithograph. 1895.
Signed with the Butterfly. 20.8 × 15cm. (8⅛ × 6in.)
Inscribed right: 'John Grove, The Royal Lion.'
Way: 93. W: 6.

British Museum

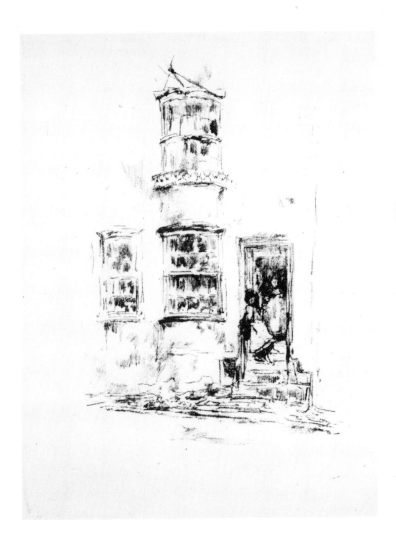

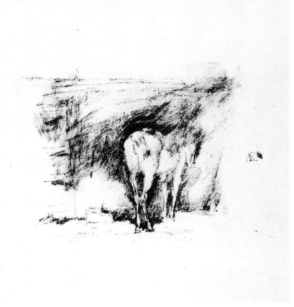

146 THE LITTLE STEPS, LYME REGIS
Lithograph. 1895.
Signed with the Butterfly. 21.1 × 14.5cm. (8⅜ × 5¾in.)
Way: 94. W: 15.

British Museum

147 STUDY OF A HORSE
Lithograph. 1895.
Signed with the Butterfly. 8.3 × 12.3cm. (3¼ × 4⅞in.)
Way: 95. W: 4.

British Museum

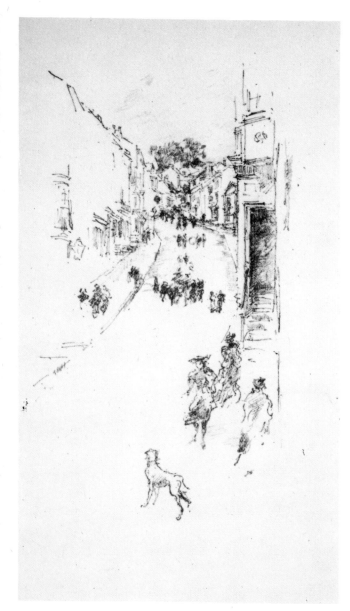

148 SUNDAY – LYME REGIS
Lithograph. 1895.
Signed with the Butterfly. 19.5 × 10.7cm. (7¾ × 4¼in.)
Way: 96. W: 35. Reprinted by Goulding.

British Museum

149 FIFTH OF NOVEMBER
Lithograph. 1895.
Signed with the Butterfly. 16.5 × 16.5cm. (6½ × 6½in.)
Way notes that the two lines crossing the top right-hand corner
of the drawing are accidental.
Way: 97. W: 15. Reprinted by Goulding.

British Museum

150 THE OLD SMITH'S STORY
Lithograph. 1896.
Signed with the Butterfly. 20 × 15cm. (7¾ × 6in.)
Way: 98. W: 15.

British Museum

151 FIRELIGHT
Lithograph. 1896.
Signed with the Butterfly. 18.5 × 15cm. (7¼ × 6in.)
This is a portrait of Mrs Pennell.
Way: 103. W: 15.

British Museum

152 FIRELIGHT: JOSEPH PENNELL
Lithograph. 1896.
Signed with the Butterfly. 16.5 × 14cm. (6½ × 5½in.)
Way: 104. W: 15. Published in *Lithography and Lithographers*.

British Museum

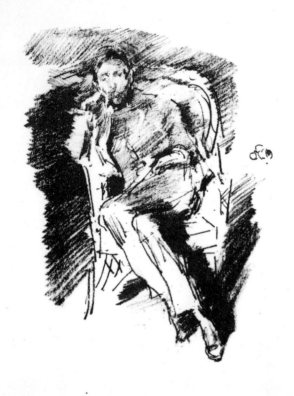

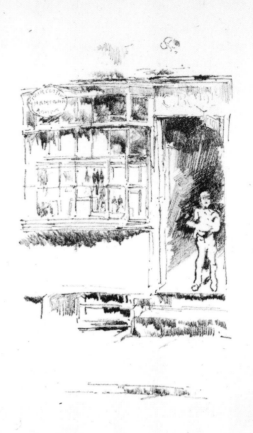

153 FIRELIGHT – JOSEPH PENNELL No. 2
Lithograph. 1896.
Signed with the Butterfly. 16.5 × 13cm. (6½ × 5⅛in.)
Way: 105. W: 15.
Another version of 152.

British Museum

154 THE BARBER'S SHOP IN THE MEWS
Lithograph. 1896.
Signed with the Butterfly. 19 × 12cm. (7½ × 4¾in.)
Way: 106. W: 9.
This was a little shop **near** Bond Street.

British Museum

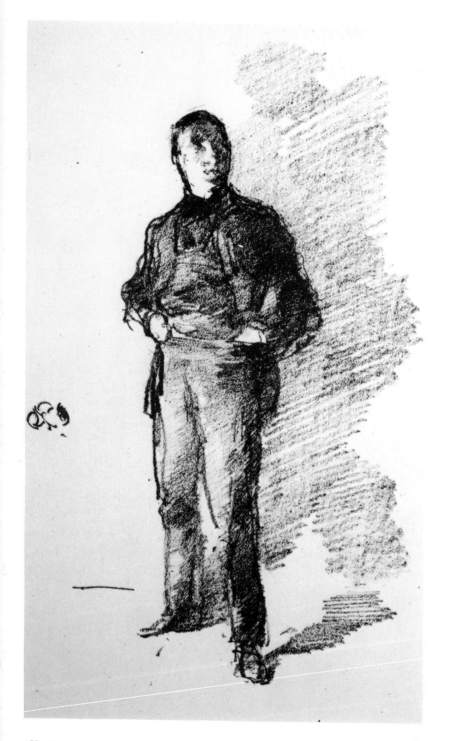

155 STUDY NO. 1 PORTRAIT OF THOMAS WAY
Lithograph. 1896.
Signed with the Butterfly. 18.7 × 12cm. (7⅜ × 4¾in.)
Thomas Way encouraged Whistler to take up lithography and printed most of his stones. His son, Thomas R. Way wrote the standard catalogue of Whistler's lithographs. After the quarrel between the artist and the Way family in 1896, Whistler withdrew all his stones from their keeping, and many were subsequently printed by Frederick Goulding. See Notes on the Plates. Way: 107. W: 10.

British Museum

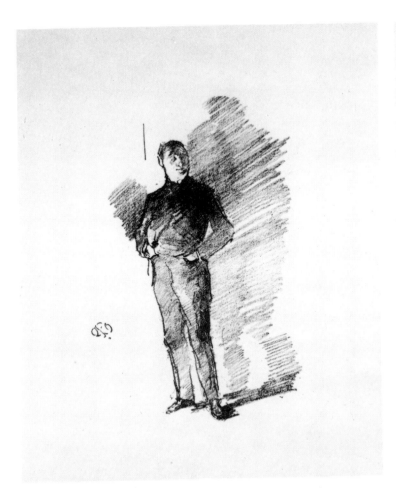

156 STUDY NO. 2 PORTRAIT OF THOMAS WAY
1896.
Signed with the Butterfly. 16.7 × 11cm. (6⅝ × 4⅛in.)
Way: 108. W: 6.
Another, but smaller version of 155.

British Museum

157 Undescribed and unrecorded by Way this is presumably a
cancelled study for 155 and 156. Size unknown.

British Museum

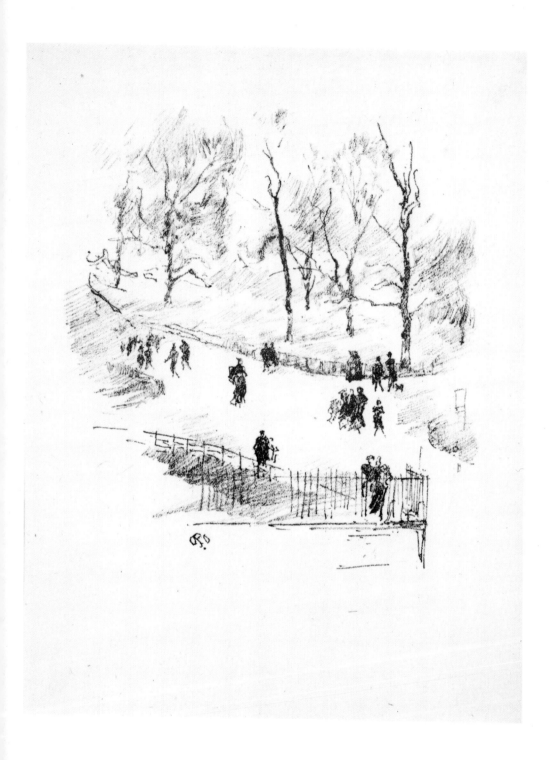

158 KENSINGTON GARDENS
Lithograph. 1896.
Signed with the Butterfly. 15.5 × 14.5cm. (6⅛ × 5¾in.)
Way: 109. W: 12.

British Museum

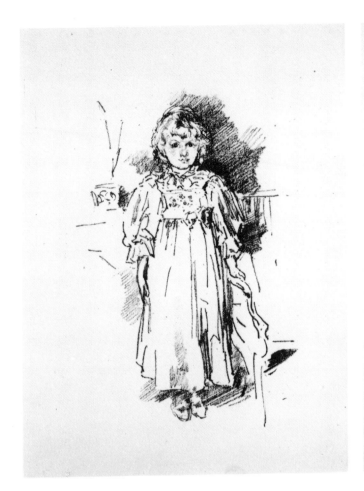

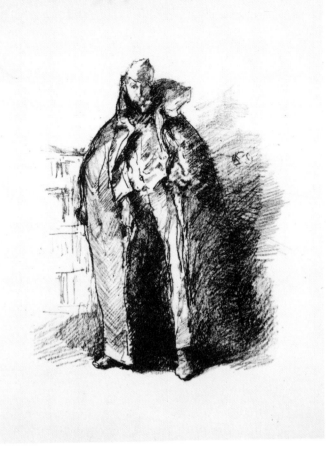

159 LITTLE EVELYN
Lithograph. 1896.
Signed with the Butterfly. 16 × 11.4cm. (6½ × 4½in.)
Way: 110. W: 15. Published in the *Art Journal*.

British Museum

160 THE RUSSIAN SCHUBE
Lithograph. 1896.
Signed with the Butterfly. 17.7 × 14.8cm. (7 × 5⅞in.)
Way: 112. W: 15.
This is a portrait of Joseph Pennell wrapped in a
Russian Greatcoat.

British Museum

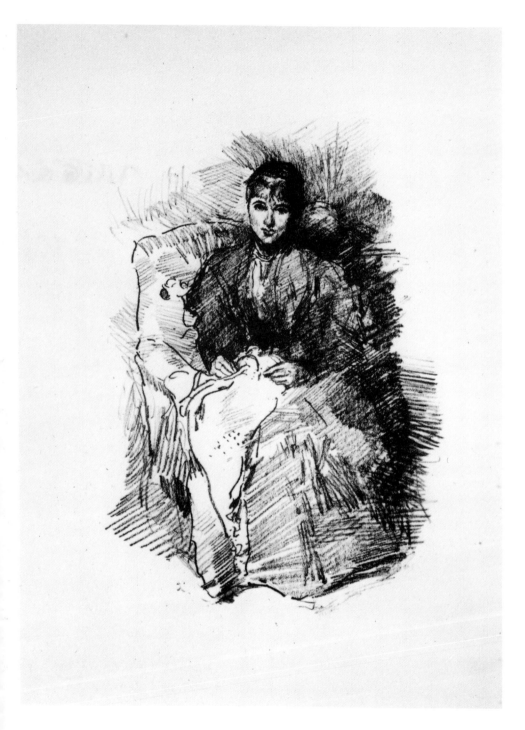

161 NEEDLEWORK
Lithograph. 1896.
Signed with the Butterfly. 19.2 × 14.3cm. (7⅝ × 5⅝in.)
Way: 113. W: 15. Reprinted by Goulding.
The sitter was Miss Rosalind Birnie Philip.

British Museum

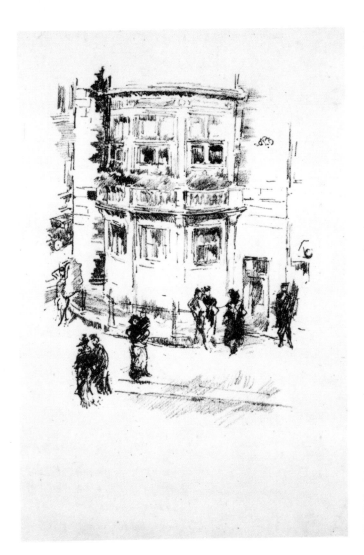

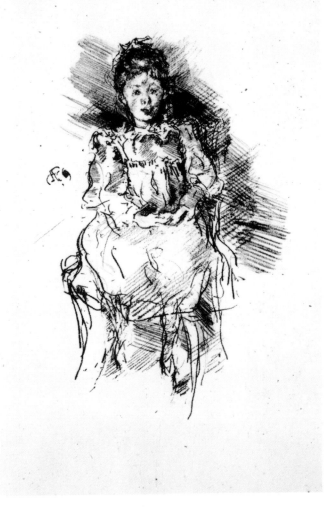

162 THE MANAGER'S WINDOW, GAIETY THEATRE
Lithograph. 1896.
Signed with the Butterfly. 17.8 × 13.7cm. (7 × 5⅜in.)
Way: 114. W: 15. Reprinted by Goulding.

British Museum

163 LITTLE DOROTHY
Lithograph. 1896.
Signed with the Butterfly. 19 × 13.5cm. (7½ × 5⅜in.)
Way: 115. W: 4.

British Museum

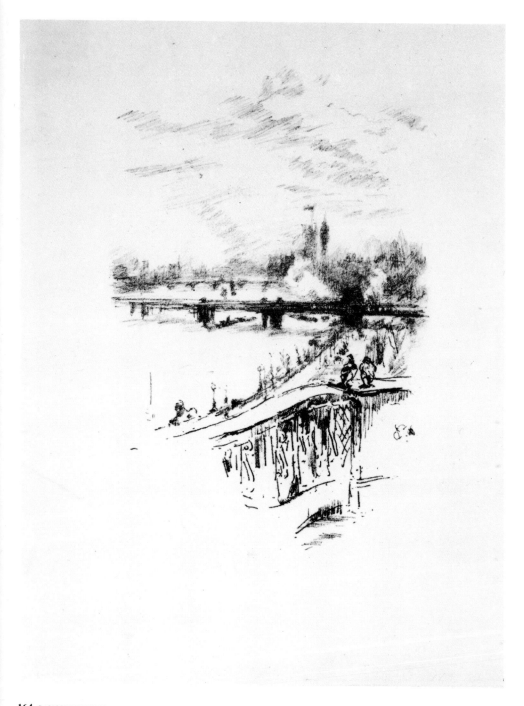

164 SAVOY PIGEONS
Lithograph. 1896.
Signed with the Butterfly. 19.6 × 13.7cm. (7¾ × 5⅜in.)
A view of the Thames looking towards Westminster, and
drawn from a balcony of the Savoy Hotel.
Way: 118. W: 23. Reprinted by Goulding.
Published in *The Studio*. Studio Stamp.

British Museum

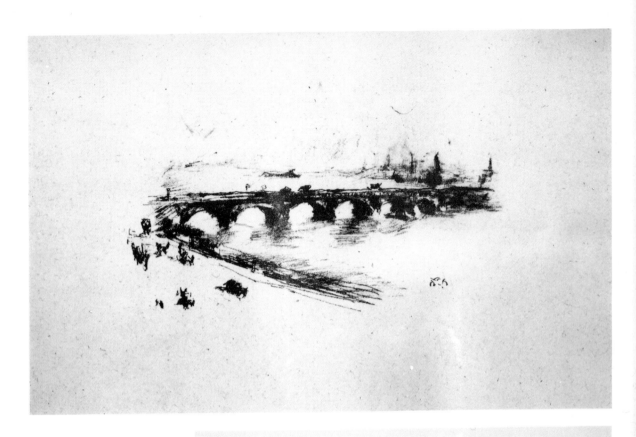

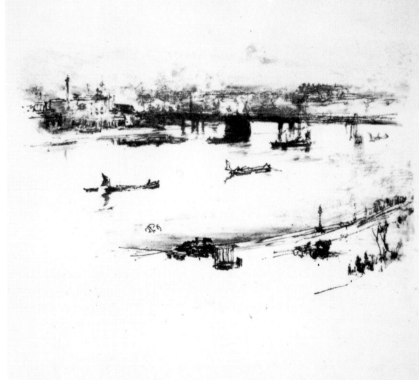

165 EVENING – LITTLE WATERLOO BRIDGE
Lithograph. 1896.
Signed with the Butterfly. 12.1 × 19cm. (4¾ × 7½in.)
Way: 119. W: 26.

British Museum

166 CHARING CROSS RAILWAY BRIDGE
Lithograph. 1896.
Signed with the Butterfly. 13 × 21cm. (5⅛ × 8⅜in.)
Way: 120. W: 27.

British Museum

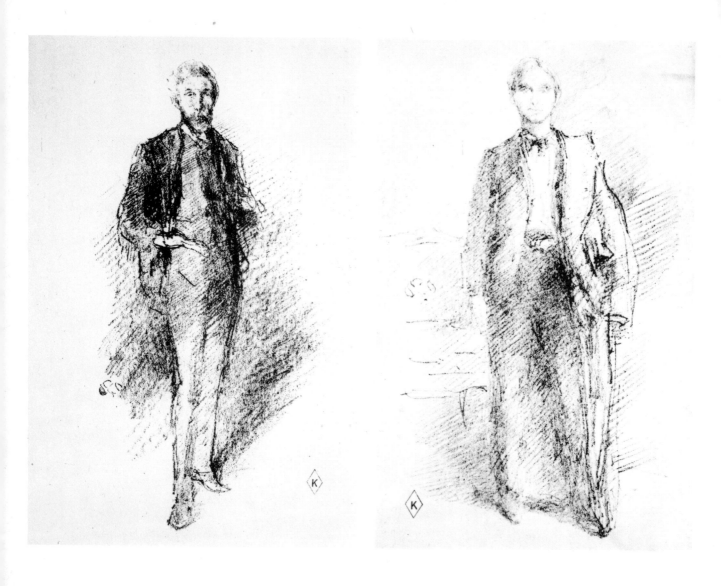

167 STUDY: JOSEPH PENNELL
Lithograph. 1896.
Signed with the Butterfly. 20 × 10.5cm. (7¾ × 4⅛in.)
Way: 111. W: 6.

British Museum

168 PORTRAIT STUDY OF MR A. J. POLLITT
Lithograph. 1896.
Signed with the Butterfly. 19 × 12cm. (7½ × 4¾in.)
Way: 117. W: 4.

British Museum

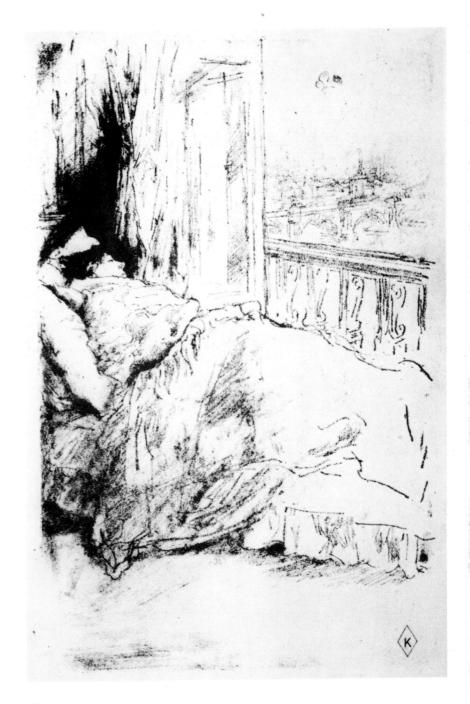

169 BY THE BALCONY
Lithograph. 1896.
Signed with the Butterfly. 21.5 × 14cm. (8¼ × 5½in.)
Way: 124. W: 6.
This is one of a group of studies of the artist's wife, Trixie,
made at the Savoy Hotel, London. As with Plate 174. *The Siesta*,
proofs of this lithograph were only stintingly released by the
artist.

British Museum

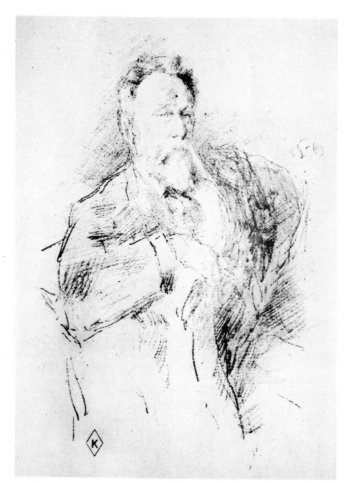

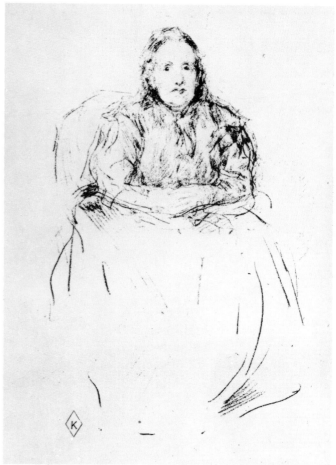

170 SKETCH OF W. E. HENLEY
Lithograph. 1896.
Signed with the Butterfly. 16.5 × 13.3cm. (6½ × 5¼in.)
Way: 127. W: 6.
At the time Whistler made this study, Henley was Editor of *The National Observer.*

British Museum

171 PORTRAIT STUDY
Lithograph. 1896.
Signed with the Butterfly. 18.5 × 11.4cm. (7¼ × 4½in.)
Way: 116. W: 8.

British Museum

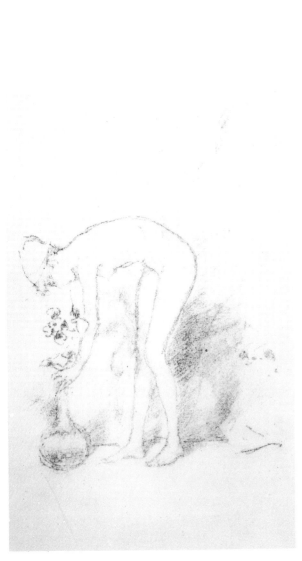

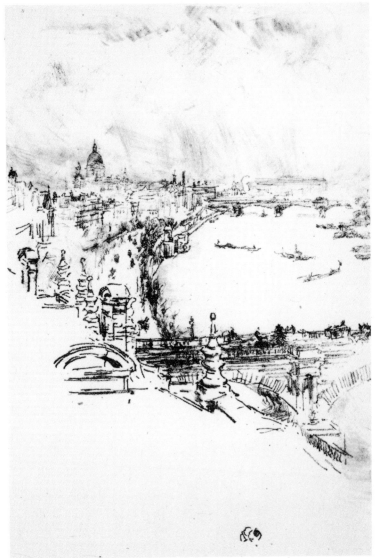

172 A NUDE MODEL ARRANGING FLOWERS
Lithograph. *c.* 1890–96.
Unrecorded by Way.
The Catalogue of the Colnaghi Exhibition (No: 253) dates this print as 1896–98. Professor Young believes it to have been made earlier, and it is his dating which is given here. It is likely he argues that the subject may well be the girl who appears in *The Little Model Resting* of 1890 (Plates 43 and 44).
However since there is no conclusive corroboration for this view the final date bracket chosen is a wide one.

Moselle Taylor Meals Collection (Cleveland Museum of Art, U.S.A.)

173 LITTLE LONDON
Lithograph. 1896.
Signed with the Butterfly. 18.7 × 13.6cm. ($7\frac{3}{8}$ × $5\frac{3}{8}$in.)
Way: 121. W: 30. Reprinted by Goulding.
Drawn from the Savoy Hotel, where Whistler stayed while his wife was fatally ill with cancer.

British Museum

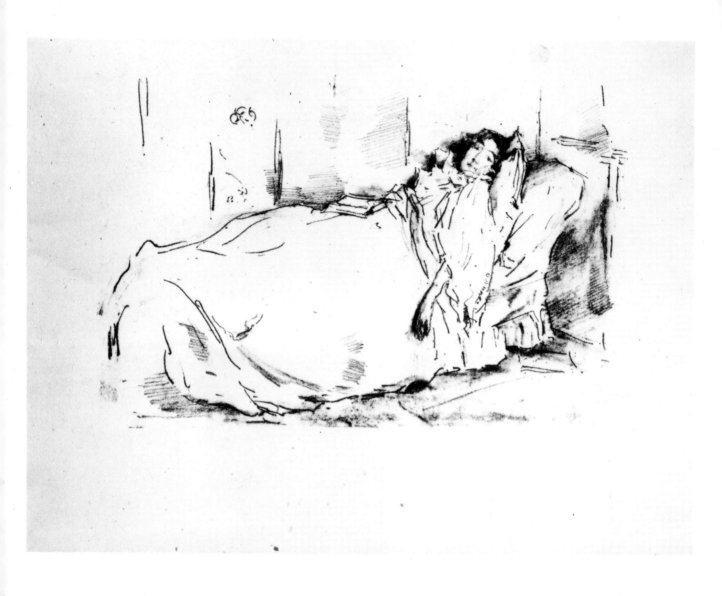

174 THE SIESTA
Lithograph. 1896.
Signed with the Butterfly. 13.6 × 21cm. (5¾ × 8¼in.)
Way: 122. W: 31.
See note to Plate 169.

British Museum

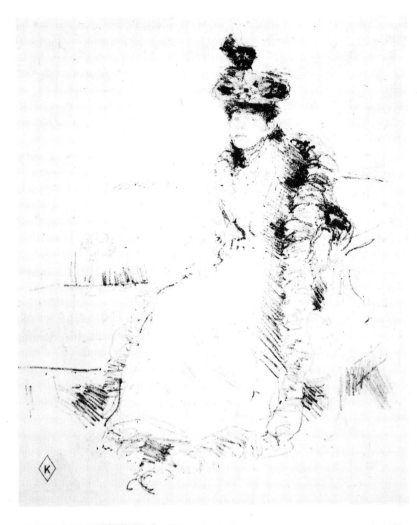

175 A LADY SEATED
Lithograph. 1896.
Signed with the Butterfly. 19 × 16.8cm. (7½ × 6⅝in.)
Way: 152. Printed in Paris.

British Museum

176 LADY AND CHILD
Lithograph. 1896.
Signed with the Butterfly. 14.9 × 23cm. (5⅞ × 8⅞in.)
Way: 157. Printed in Paris.

British Museum

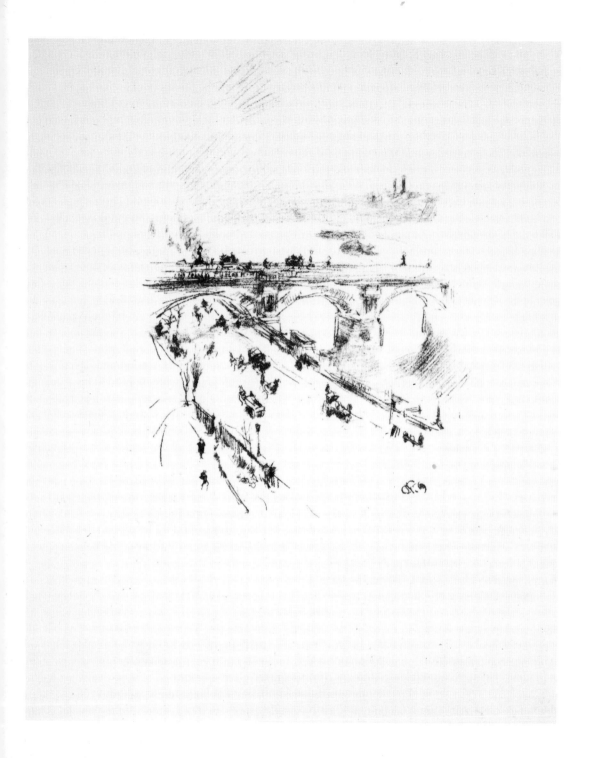

177 WATERLOO BRIDGE
Lithograph. 1896.
Signed with the Butterfly. 16.7 × 12.6cm. (6⅝ × 5in.)
Way: 123. W: 26.

British Museum

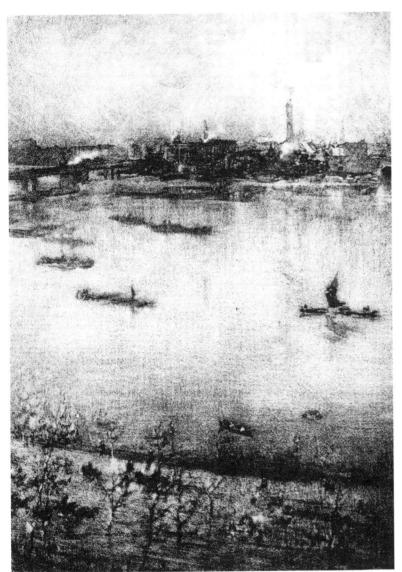

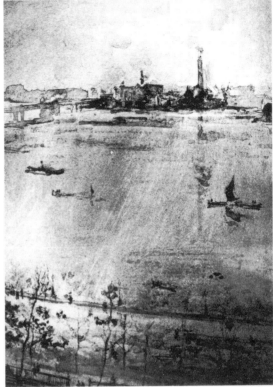

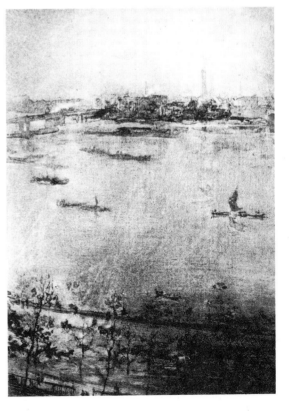

178 THE THAMES
Lithotint. 1896.
Signed with the Butterfly. 26.5 × 18.7cm. (10½ × 7⅜in.)
Way: 125. W: 12. Reprinted by Goulding.
The stone was worked from an upper room in the Savoy Hotel.

British Museum

179 and **180** First and second states of 178.
In the first state (179) the expanse of river has not yet been
cleaned, or other tonal modifications effected. The middle state
(180) shows the modification work in progress.
Way records that about six proofs were taken of the first state,
and about ten of the middle state.
Way: 125A and 125B.

British Museum

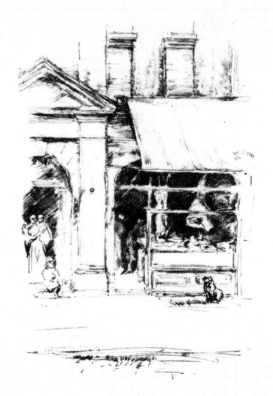

181 ST ANNE'S SOHO
Lithograph. 1896.
Signed with the Butterfly. 19 × 13cm. (7½ × 5⅛in.)
Way: 126. W: 23. Reprinted by Goulding.

British Museum

182 THE BUTCHER'S SHOP
Lithograph. 1896.
Signed with the Butterfly. 18.2 × 13cm. (7⅛ × 5¼in.)
Way: 128. W: 21. Reprinted by Goulding.
Way lists four states of this subject. Only a few copies of the
first three states were printed. The differences are slight, and
relatively indistinguishable from the fourth, and final state.

British Museum

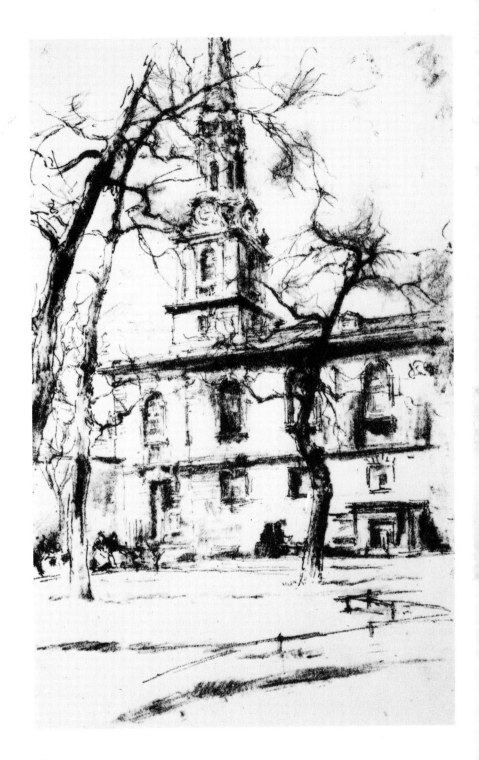

183 ST GILES-IN-THE-FIELDS
Lithograph. 1896.
Signed with the Butterfly. 21.5 × 14cm. (8½ × 5½in.)
Way: 129. W: 8. Reprinted by Goulding.

British Museum

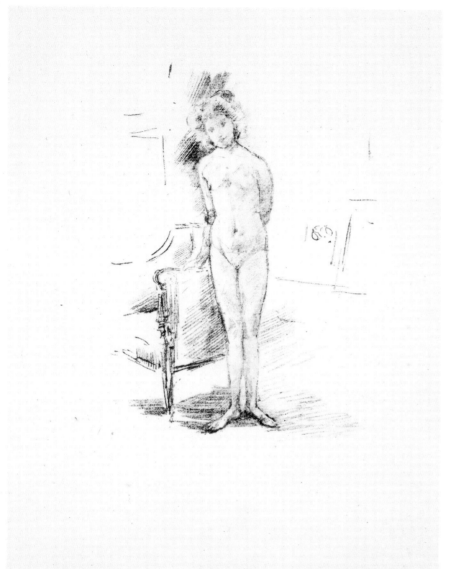

184 LITTLE LONDON MODEL
Lithograph. 1896.
Signed with the Butterfly. 17 × 12.7cm. (6¾ × 5in.)
Way: 130. W: 8.

British Museum

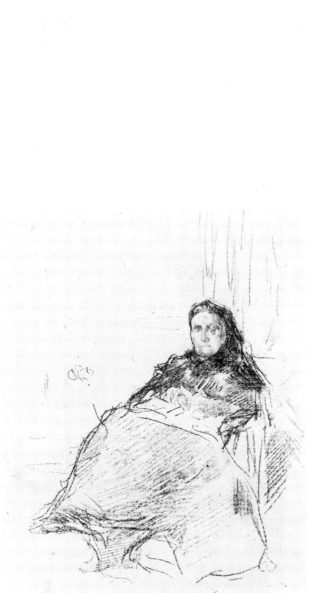

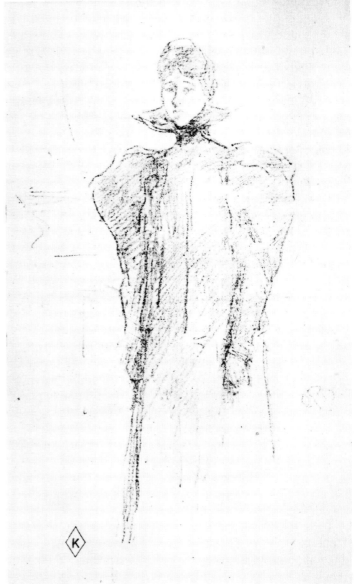

185 PORTRAIT STUDY – MRS PHILIP No. 2
Lithograph. *c.* 1894–96.
Signed with the Butterfly. 19 × 14.1cm. (7½ × 5$\frac{9}{16}$ in.)
Unrecorded by Way.

University of Glasgow. Birnie Philip Bequest

186 THE MEDICI COLLAR
Lithograph. *c.* 1895–96.
Signed with the Butterfly. 17.7 × 10.1cm. (7 × 4in.)
Way: 153. Printed in Paris.

British Museum

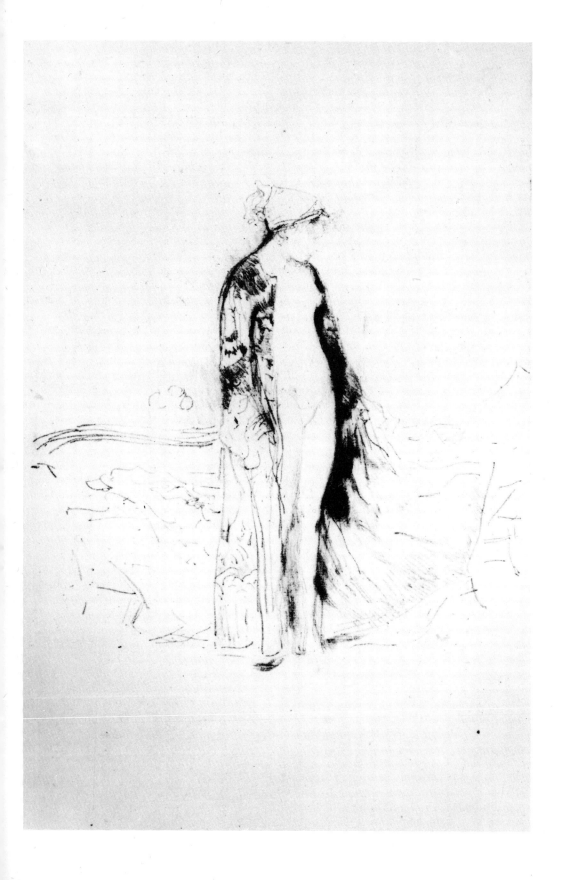

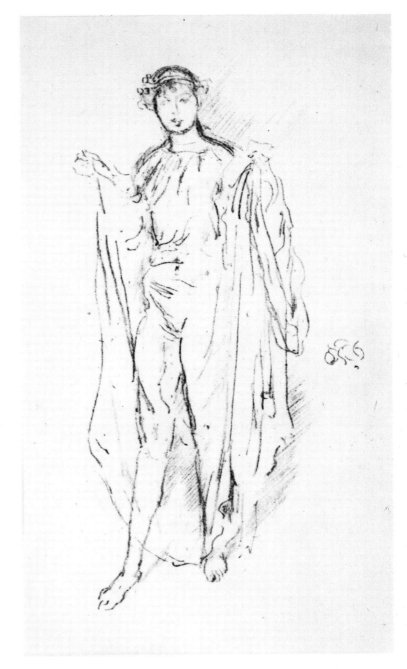

187 A DRAPED MODEL STANDING BY A SOFA
Lithograph. *c.* 1893–95.
Not recorded by Way.
The Colnaghi Catalogue (No. 254) dates this as *c.* 1898(?). Professor Young however prefers to date it earlier. The sofa he argues is found in a number of the paintings and pastels made in France, and the way in which the model's hip sticks out is similar he feels to a painting in the Glasgow Collection which he is inclined to date between 1893 and 1895 during which time Whistler was again living and working in Paris. He first lived there from 1855–58.

Collection: *Mr Paul Walter.* U.S.A.

188 THE GIRL
Lithograph. 1896–98(?)
Signed with the Butterfly.
Way: 159. Printed in Paris.

P & D Colnaghi & Co

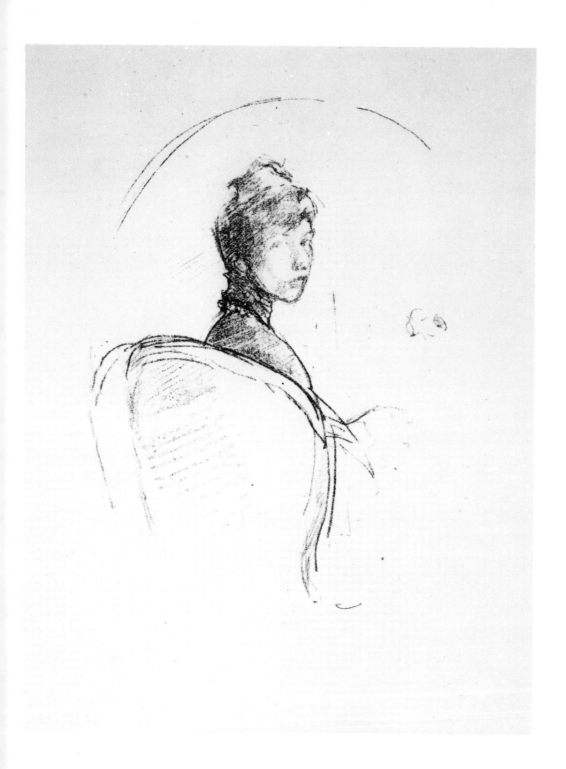

189 PORTRAIT STUDY: MISS ROSALIND BIRNIE PHILIP
Lithograph. *c*. 1900.
Unrecorded by Way.

P & D Colnaghi & Co

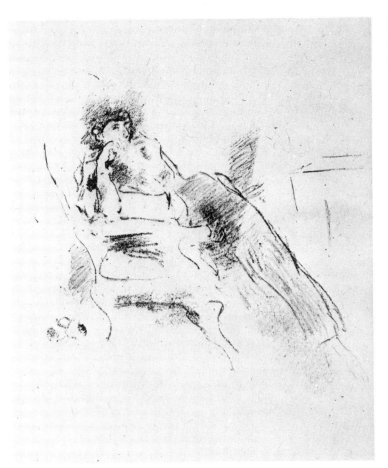

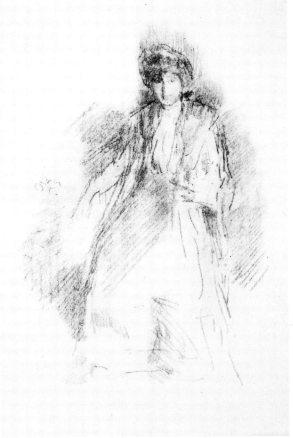

190 LADY RECLINING IN AN ARMCHAIR
Lithograph. *c.* 1894–1900.
Signed with the Butterfly. 12.7 × 12.7cm. (5 × 5in.)
Unrecorded by Way.
Professor Young considers that the subject is likely to be a member of the family; probably Ethel (Mrs Whibley).

University of Glasgow, Birnie Philip Bequest

191 DOROTHY SETON IN HAT
Lithograph. *c.* 1902–3.
Unrecorded by Way. 40.5 × 13.3cm. (16 × 5¼in.)
Professor Young notes that although the Colnaghi Catalogue dates both this lithograph and *Dorthy Seton* (Plate 192) *c.* 1900, they should he argues be more properly and probably dated as of the period 1902–1903. He points out that the Pennells in their *Whistler Journal* (Philadelphia, 1921, pages 286–87) write that Dorothy Seton was Whistler's last model during the period from April 1902 until his death in 1902. The Pennells also record that Dorothy Seton was sitting for the artist on 20 October 1902.

University of Glasgow, Birnie Philip Bequest

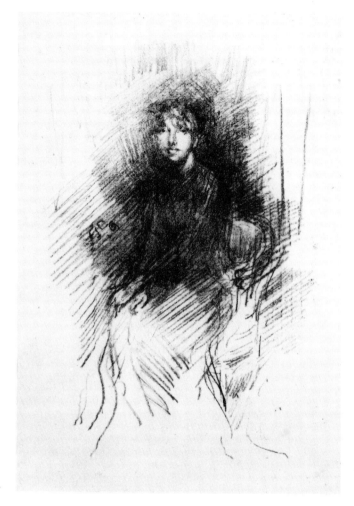

192 DOROTHY SETON
Lithograph. *c.* 1902–3.
Unrecorded by Way.
See note to Plate 191.

Collection: *Mrs M. Oddie*

193 FIGURE STUDY IN FOUR COLOURS
Lithograph. 1890 (*See* p. 126) Plates 193–196 are reproduced in
colour on pp. 9, 13, 21 and 24 respectively.
Signed with the Butterfly. 20×14.2cm. ($7\frac{7}{8} \times 5\frac{5}{8}$in.)
Whistler's first experiment in colour lithography. It was never
finally completed, and only a few impressions were pulled.
Four Colour process: red, rose, bluish-green and black. Some
impressions in black and white.
Way: 99. W: 8. Printed in Paris.

British Museum

194 DRAPED FIGURE RECLINING
Lithograph in Colours. *c.* 1890–92. (*See* p. 13)
Signed with the Butterfly. 17×25.5cm. ($6\frac{3}{4} \times 10$in.)
Printed in six colours: grey, green, pink, yellow, blue and
purple.
Way: 156. Printed in Paris.

British Museum

195 RED HOUSE, PAIMPOL
Lithograph in Colours. 1893 (*See* p. 21)
Signed with the Butterfly 22.8×16.7cm. ($9 \times 6\frac{5}{8}$in.)
Printed in Three colours: red, grey and black.
This is one of the two colour lithographs Whistler made in
1893, the other being *The Yellow House, Lannion.*
Way: 100. Printed in Paris.

British Museum

196 THE YELLOW HOUSE, LANNION
Lithograph in Colours. 1893. (*See* p. 24)
Printed in four colours: yellow, green, grey and black.
This is one of the two colour lithographs made by Whistler in
1893, the other being the *Red House, Paimpol.*
Way: 101.

P & D Colnaghi & Co